GAUGUIN

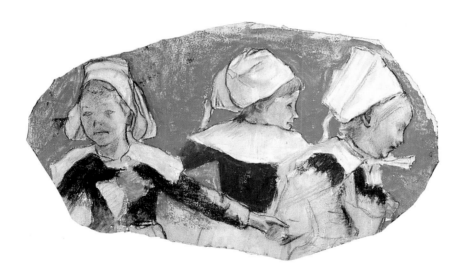

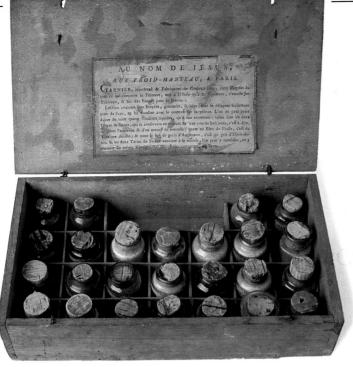

19th-century box of pigments

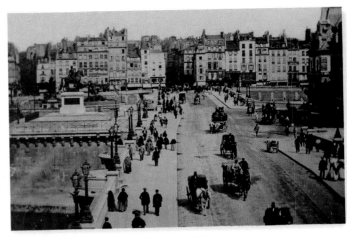

Paris, 1858

Carved and
decorated cane

Tahitian arrow quiver

Carved
spoons

Arearea, 1892

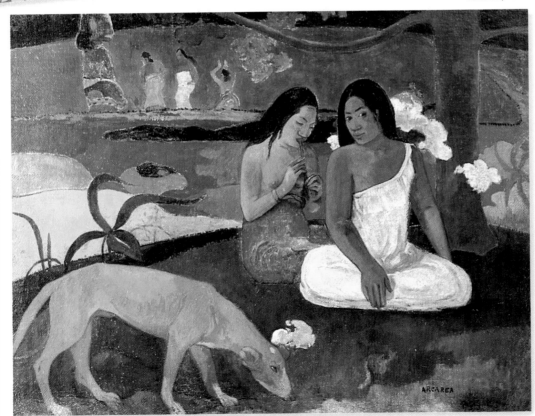

Goose pot

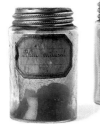

Powdered
pigments

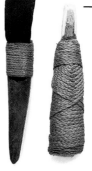

Tahitian
carving tools

GAUGUIN

MICHAEL HOWARD

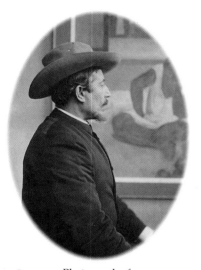

Photograph of
Gauguin, 1893–94

Woman with a Flower, 1891

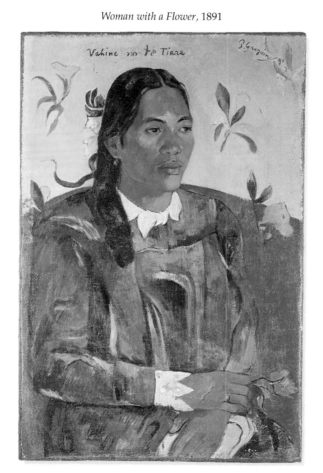

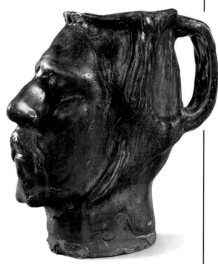

*Self-portrait in the
Form of a Jug*

Exhibition
catalog

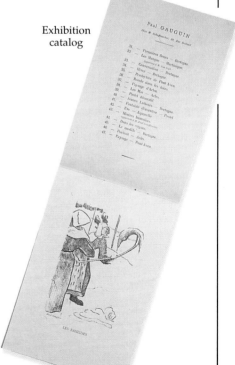

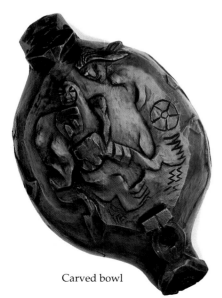

Carved bowl

DK

DORLING KINDERSLEY
London • New York • Stuttgart
in association with
THE MUSÉE GAUGUIN, TAHITI

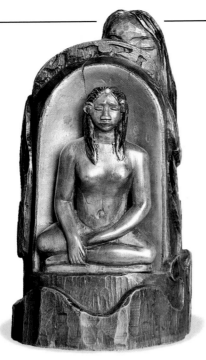

Letter to Emile
Schuffenecker

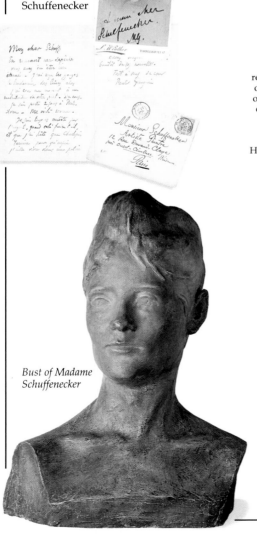

Idol with a Pearl

Bust of Madame
Schuffenecker

Page from
Noa Noa

Satirical
journals

DK

A DORLING KINDERSLEY BOOK

Project editor Gwen Edmonds
Assistant editor Luisa Caruso
Art editor Arthur Brown
Series art editor Toni Rann
Managing editor Sean Moore
Managing art editor Tina Vaughan
U.S. editor Laaren Brown
Picture researcher Julia Harris-Voss
Production controller Meryl Silbert
Page make-up The Cooling Brown Partnership

First American Edition, 1992
10 9 8 7 6 5 4 3 2 1

Published in the United States by
Dorling Kindersley, Inc., 232 Madison Avenue
New York, New York 10016

Library of Congress Cataloging-in-Publication Data

Howard, Michael. 1954-
 Gauguin / Michael Howard. -- 1st American ed.
 p. cm. --- (Eyewitness art)
 Includes index.
 ISBN 1-56458-066-0
 1. Gauguin, Paul, 1848-1903--Criticism
 and interpretation.
 I. Title. II. Series.
 ND553.G27H67 1992
 759.4--dc20 92-7067
 CIP

Color reproduction by GRB Editrice s.r.l.
Printed in Italy by A. Mondadori Editore, Verona

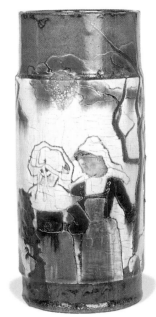

*Vase decorated with
Breton scenes*

Sketches from the
Brittany sketchbook

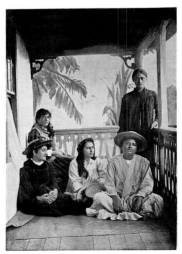

Photograph of
South Sea islanders

Contents

6
The formative years

8
Early work

10
Escape to Brittany

12
Peasant life

14
Panama and Martinique

16
Picking fruit

18
Tropical landscape

20
The artists in Pont-Aven

22
A new vision

24
Life with Vincent

26
Portraits of the artist

28
The Universal Exhibition

30
Staying with Schuffenecker

32
A solemn portrait

34
Le Pouldu

36
The suffering artist

38
The South Seas

40
Greeting a new world

42
In search of lost gods

44
Spirits of the dead

46
Pastoral scenes

48
Return to Paris

50
Savage sculpture

52
Difficult times

54
Fundamental questions

56
A barbaric nude

58
The final years

60
Gauguin's legacy

62
Key dates • Gauguin collections

63
Glossary • Works on exhibit

64
Index • Acknowledgments

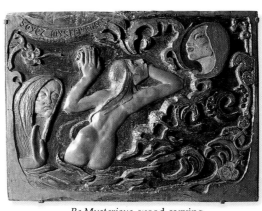

Be Mysterious, wood carving

The formative years

GAUGUIN'S GRANDMOTHER
Flora Tristan, Gauguin's grandmother, was an early feminist and adventuress.

Bᴏʀɴ ɪɴ 1848, Paul Gauguin was the only son of Clovis Gauguin, a radical republican journalist, and his wife, Aline. His father's political activities forced the family into exile in 1849. They headed for Lima, the capital of Peru, to stay with relatives. Clovis Gauguin died en route, but the rest of the family remained in Peru for four years. Paul Gauguin's later description of himself as a "savage from Peru," suggests the impact of these years. By the age of seven, he was back in France, at school in Orléans; later he was enrolled at the pre-naval college in Paris. From there he went on to travel the world as a professional sailor.

LIFE IN LIMA
The grandeur of Lima's Baroque architecture, the colorful clothing of the people, and the almost continual sunshine would have etched themselves deeply in Gauguin's memory.

The life of a sailor

Gauguin's early memories of his exotic home were strongly felt, and at the age of 17 he joined the French merchant navy, traveling the world for the next six years. He was destined to be a wanderer for much of his life, never really settling in one place.

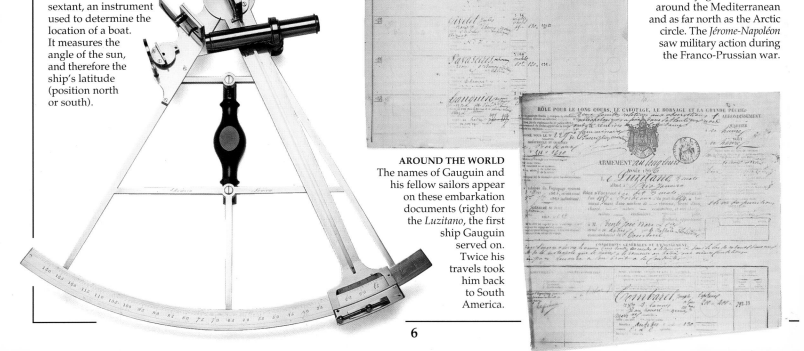

THE MILITARY MAN
Gauguin worked on the ship *Jérome-Napoléon* (above). He registered as a professional sailor, third class, in 1868. His voyages took him all around the Mediterranean and as far north as the Arctic circle. The *Jérome-Napoléon* saw military action during the Franco-Prussian war.

SEXTANT
As a marine, Gauguin would have known how to handle a sextant, an instrument used to determine the location of a boat. It measures the angle of the sun, and therefore the ship's latitude (position north or south).

AROUND THE WORLD
The names of Gauguin and his fellow sailors appear on these embarkation documents (right) for the *Luzitano*, the first ship Gauguin served on. Twice his travels took him back to South America.

6

PARISIAN STOCKBROKER

After the death of his mother in 1867, Gauguin's welfare was in the hands of his wealthy guardian, Gustave Arosa. In 1871, Arosa helped him to secure a very desirable job at a Parisian brokerage firm. However, Arosa's greatest influence on his charge was through his large art collection, which included works by Camille Pissarro and Eugène Delacroix.

A view of Paris in 1858, when Gauguin was ten years old

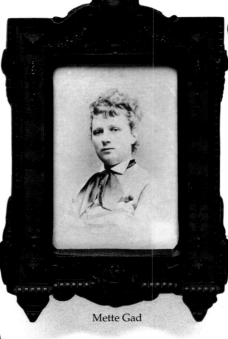

Paul Gauguin

GAUGUIN GETS MARRIED

In 1873, the year these photographs were taken, Gauguin married Mette Gad, a young woman from a respectable Danish family. Already an enthusiastic amateur painter, the year of his wedding coincided with Gauguin's first acceptance at the Salon.

Mette Gad

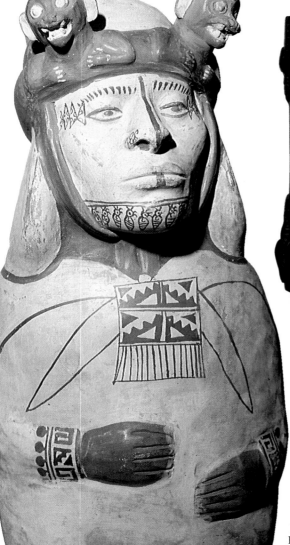

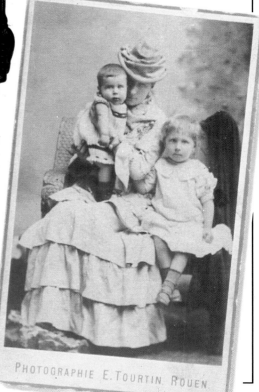

A GROWING FAMILY

This photograph shows Mette with two of their children. Their settled life in Paris came to an end in 1882, when a crisis rocked the Parisian financial markets, leaving Gauguin without a job. The family moved first to Rouen, and then to Copenhagen, in an attempt to stabilize their fortunes.

PERUVIAN POTTERY

Gauguin's mother was a collector of Pre-Columbian Peruvian pots, which were to influence Gauguin throughout his life. She left him her art collection, but held little hope for her son, predicting that he was "going to find himself completely on his own," because of his difficult, uncompromising manner.

PHOTOGRAPHIE E. TOURTIN ROUEN

Early work

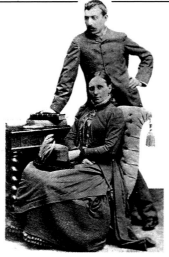

Paul and Mette Gauguin together in Copenhagen

Passionately interested in art, and already a proficient amateur painter, Gauguin was a shrewd collector of Impressionist paintings. Gauguin's transition from wealthy stockbroker to full-time artist came after the financial crash of 1882; he resigned the following year, probably with few regrets. His recent success at the sixth Impressionist exhibition may well have confirmed his belief that it would be possible for him to have a prosperous career as an avant-garde painter. Although he had maneuvered himself into the Impressionist circle with the help of Camille Pissarro, his temperament and obvious ambition made his fellow painters wary and suspicious of him.

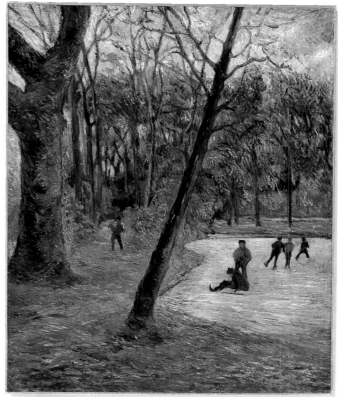

SKATERS ON FREDERIKSBERG LAKE
1884; 25½ x 21¼ in (65 x 54 cm)
Gauguin's use of broken, rhythmical brushwork, and his interest in texture and color, can be related directly to the work of the Impressionist artists.

BUST OF METTE GAUGUIN
This marble bust of his wife, sculpted in 1879, reveals much of Gauguin's considerable technical ability, but very little of Mette's personality. It also demonstrates that Gauguin's later rejection of conventional techniques was a conscious choice. His decision to become an artist eventually meant the breakdown of his family life. In 1885, he left Mette and his children in Copenhagen. They never lived together as a family again.

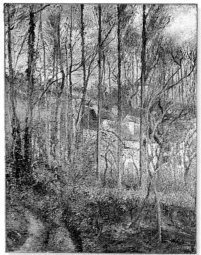

THE COTE DES BOEUFS AT L'HERMITAGE
Camille Pissarro; 1877; 45 x 34½ in (114 x 87.5 cm)
Impressed by Pissarro's carefully constructed paintings, Gauguin was a collector of his work, and he had encouraged his fellow stockbrokers to do likewise.

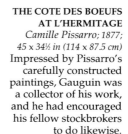

PISSARRO BY GAUGUIN; GAUGUIN BY PISSARRO
This intimate double portrait is a testimony to the friendship of the two artists. Pissarro introduced Gauguin to the techniques and the subject matter of the Impressionists. In years to come, Pissarro would be highly critical of Gauguin's abandonment of naturalistic painting.

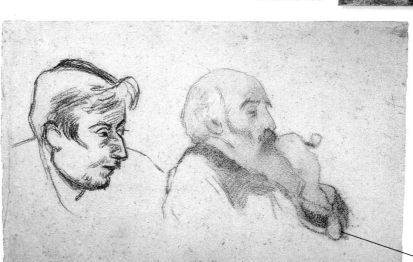

A white marble bust, sculpted in a traditional style

Gauguin sketched Pissarro in pastels; Pissarro used black chalk

Nude Study

1880; 43½ x 31 in (114.5 x 79.5 cm)

Despite its modest title, this is an ambitious painting, which was exhibited at the sixth Impressionist exhibition of 1881. It was praised for its refreshing realism by the novelist and critic J. K. Huysmans; he felt that it recalled the genius of Rembrandt.

DUTCH INFLUENCE

The technical aspects of this painting seem to have greatly concerned Gauguin. The way the light falls, and the arrangement of the forms on the canvas, suggest an interest in the work of the 17th-century Dutch painter Jan Vermeer, who painted figures in domestic settings.

NATURAL NUDE

Compared with traditional 19th-century nudes, Gauguin's plain figure is natural and unidealized. He may have been inspired by the pastel nudes of Edgar Degas. In an age when women's bodies were covered from head to foot, works such as this one were imbued with an aura of sexuality.

BRUSH STROKES

The composition of the picture and the handling of the paint reveal the hesitancy that is so noticeable in Gauguin's early work. In this painting, he is experimenting with the Pointillist style of Georges Seurat – the technique of applying dashes of pure color to achieve an overall harmonized effect. Seurat's new approach challenged the older Impressionists' belief in spontaneity.

DIGNITY AND MYSTERY

Gauguin went on to paint many women, both Breton and Tahitian, and, as with this nude, they are shown as passive and inward-looking. Rather than showing an obviously active participation in life, Gauguin celebrates the dignity, mystery, and significance of the inner being.

EXOTIC PROPS

A balance of naturalism and artifice, this painting presents a naked woman in an everyday domestic pursuit, surrounded by exotic props – a mandolin and a brightly colored rug. The act of sewing would also have helped keep the model occupied.

Escape to Brittany

A Pont-Aven painter returning from a hard day's work

AT SOME DISTANCE FROM PARIS, in Pont-Aven, Brittany, Gauguin began to develop the simple and primitive hallmarks of his style. Gauguin had submitted 19 works to the eighth and final Impressionist show, but his Pissarro-like works were overshadowed by the cool cosmopolitan paintings of the young Georges Seurat. Gauguin's need to live cheaply and to develop his own artistic personality in a sympathetic setting, far from the competitiveness of Paris, prompted his first excursion to Brittany in July 1886. In this respect, he was just one of many painters who flocked to the remote Breton region every summer to find attractive landscapes and willing models who were accustomed to posing for artists.

ARTISTS AND ARTISANS
These simple sketches, from Gauguin's Breton sketchbook, of a Breton woman and a fellow artist drinking absinthe, show both sides of the community in Pont-Aven. The strong religious beliefs and the quaint traditional costumes of the Breton women were a recurrent theme in Gauguin's Brittany paintings. The sketch of the artist is an unusual subject for Gauguin; it is not one that appeared in his paintings.

PAINTING OUTDOORS
This cartoon from a popular magazine of the period reveals how, by the 1880s, landscape painting had become one of the most popular and profitable genres. Artists of all abilities would congregate in Brittany; Gauguin soon established himself in the community of artists in Pont-Aven. "I am respected, and every-one here (Americans, English, Swedish, French) clamors for my advice," he wrote proudly to Mette.

THE GLOANEC INN
Surviving on a loan from a relative, the banker Eugène Mirtil, Gauguin found life in Brittany reassuringly cheap. He lodged at the Pension Gloanec, one of the cheaper inns available. Gauguin does not appear in this photograph taken outside the inn, but it was obviously a popular haunt of the artistic community.

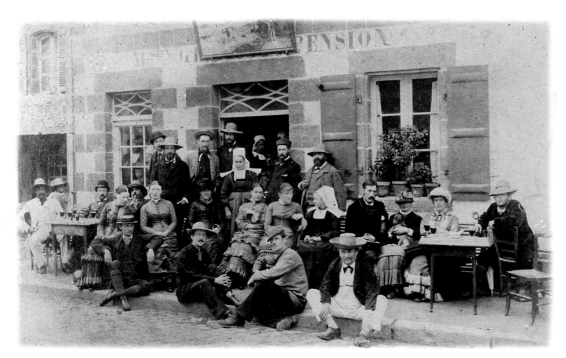

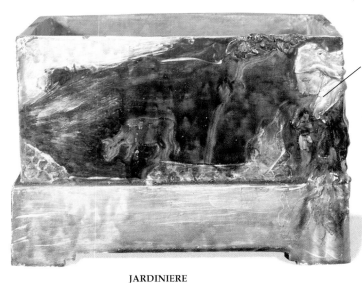

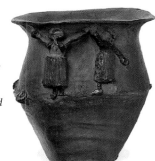

This same Breton figure appears in Gauguin's paintings and drawings

JARDINIERE

Gauguin was an accomplished sculptor, and his three-dimensional works were as important to him as his paintings. He had great hopes that his decorative and functional ceramics would provide him with a steady source of income. This is one of two *jardinières* Gauguin produced on his return to Paris, where he worked in the studio of the innovative ceramist Ernest Chaplet.

POT WITH RAISED HANDS

This charming motif recurs many times in Gauguin's ceramics. The shape and decoration of his "ceramic sculpture," as he called it, ranged from the conventional to the completely fantastical.

Molding clay

Unlike many potters, Gauguin worked his clay by hand and did not use a wheel. He may well have improvised the design as he worked.

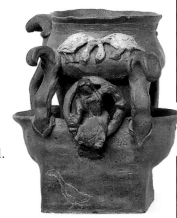

GOOSE POT

This quirky design shows a Bretonne surrounded by a circle of clay overlooked by two geese, a favorite motif of the artist. Gauguin's delight in producing decorative objects, such as this, is apparent.

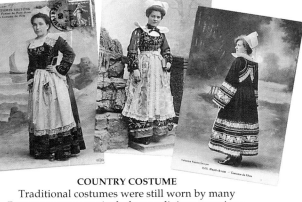

COUNTRY COSTUME

Traditional costumes were still worn by many Breton women, particularly on religious occasions. Gauguin used a "primitive" style in his paintings to enhance the accepted view of this society as deeply religious and superstitious.

FISHING SCENE

The subject of this pot is not Breton, but it may relate to the work of the English illustrators Gauguin admired so much.

LAWS OF NATURE

The centralization of French society and the sophisticated nature of Parisian life meant that an idealized image of rural life became increasingly attractive to an urban audience. Paintings, such as the one below, gave a nostalgic and essentially passive image of what was, in fact, a highly complicated and even volatile society.

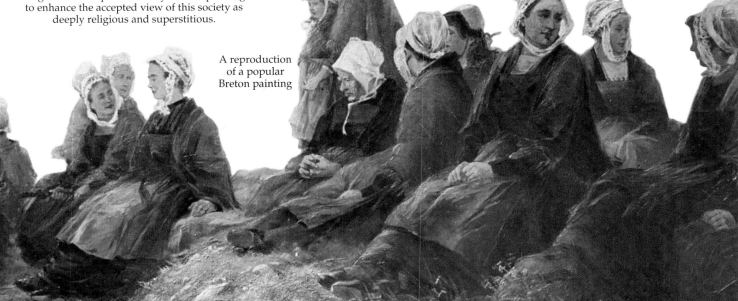

A reproduction of a popular Breton painting

Peasant life

"I LOVE BRITTANY. I find something savage, primitive here. When my clogs echo on this granite earth, I hear that dull muffled note that I am seeking in painting." Writing later of his experiences in Brittany, Gauguin was aware of its vital role in his search for a simplified style through a primitive culture and people.

A detailed sketch of a shepherd boy, from Gauguin's Breton sketchbook

In common with many of his contemporaries, Gauguin was selective in his choice of subject matter, consolidating the image of country life as never-changing and idyllic. There is a tentative quality to *The Breton Shepherdess*, and its style still owes much to Impressionism and Neo-Impressionism. However, Gauguin was trying to assert his autonomy and had escaped Paris, determined not to be seduced there by "the young chemist," Georges Seurat. Although invited, Gauguin refused to exhibit at the August 1886 Independents' exhibition in Paris, which was organized by Paul Signac and Camille Pissarro – Gauguin's one-time mentor and friend. Both Signac and Pissarro were now aligned with Seurat and with the style of Pointillism.

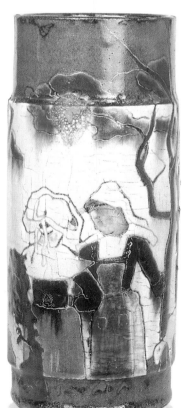

The vase is believed to have been thrown by Chaplet

VASE WITH BRETON SCENES

A collaboration between Gauguin and the famous ceramist Ernest Chaplet, this vase shows the beginnings of the cloissonné effect in Gauguin's work. Traditionally in cloissonné work, a design is created by filling in an outline with colored enamel, rather like stained glass.

STUDY FOR A PAINTING
This solid figure, one of the studies made for the painting *Four Breton Women*, also provided a design for the vase (left). The pastel echoes those of peasant women created by Pissarro during the 1880s, but the strong outlines are very much part of Gauguin's developing style. Each region of Brittany had its own folk costume, and the artist exploited their decorative potential. A distinctive feature of Pont-Aven dress was to wear the wings of the headdress asymmetrically, as Gauguin shows here.

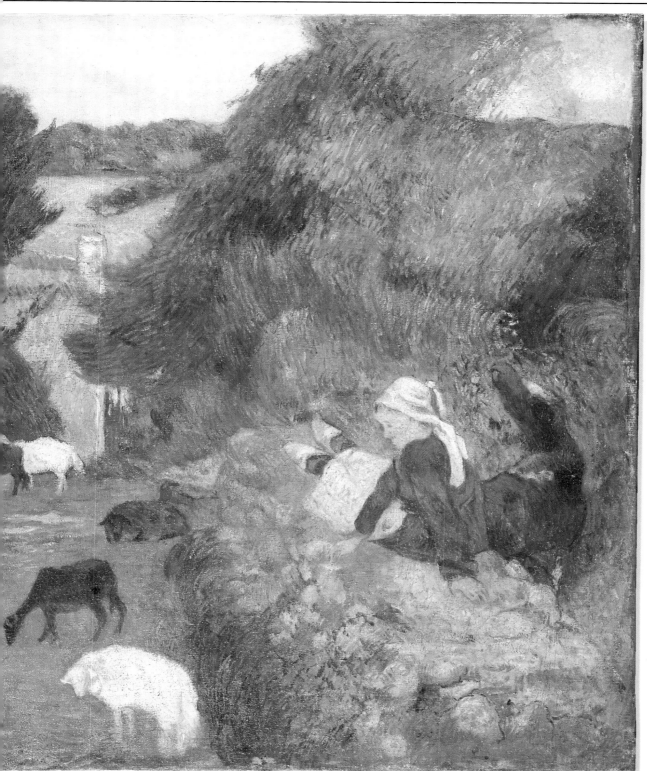

 SIMPLE SETTING
The high horizon line firmly encloses the young Breton girl within the idyllic landscape setting. Despite Gauguin's supposed rejection of Impressionism and the more scientific approach of Neo-Impressionism, their influence on his style is apparent here. The flecked brushwork and delicate tones echo the work of Pissarro (p. 8).

 FIGURES IN A LANDSCAPE
Girls, women, and animals were to be the recurring subject matter of Gauguin's art. Here, they are not loaded with any of the complicated symbolic significance that they would bear in his later paintings (pp. 46–47).

Sketches of sheep from the Breton sketchbook

REVERIE
The young shepherdess is hardly typical of peasant stock, and would never have worn her Sunday best to tend her animals. She is shown lost in thought, rather than actively going about her work.

The Breton Shepherdess

1886; 23¾ x 29 in (60.5 x 73 cm)

Conforming to the artistic practice of the day, Gauguin presents an idealized view of the countryside. It seems probable that the actual landscape was painted from nature and that figures were added later in the studio. This may account for the general awkwardness of the composition. The pose of the girl may owe something to Edgar Degas' drawings of young girls, which Gauguin admired very much. However, unlike Gauguin, Degas' models were usually in urban settings.

WATERCOLOR SKETCH
This preliminary sketch for the painting (above) is worked in charcoal and watercolor. Watercolor paints are much more suited to working outdoors than oil paints and are good to sketch with because they dry so quickly. It is probable that this sketch was painted outside, from life.

Panama and Martinique

The journey to Panama via Martinique took nearly 3 weeks

MARTINIQUE

PANAMA

"WHAT I WANT MOST is to get out of Paris, which is a wilderness for a poor man ... I am off to Panama to live like a savage." After a depressing winter in Paris, half starving, unable to sell any work, and working as a billposter, Gauguin decided to leave France. He set sail for Panama on April 10, 1887, with a young painter friend, Charles Laval. Unfortunately, the region was overwhelmed by adventurers seeking to make their fortune through the construction of the Panama Canal. Gauguin's brother-in-law, whose support they had hoped for, proved unwilling to help. The two painters soon ran out of money. In desperation, Laval painted portraits of wealthy colonialists, and Gauguin worked as a laborer for the Panama Canal Construction Company, but was laid off after only 15 days. By July, they had left Panama and were living in a small cabin on the idyllic island of Martinique, a short distance from the bay of Saint Pierre, and both were seriously ill with dysentery and malaria.

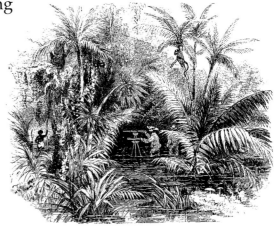

SURVEYING DIFFICULTIES
The French canal builders were faced with a difficult, swampy terrain and an unhealthy climate. Epidemics of yellow fever, dysentery, and malaria swept the region. The haven Gauguin had hoped for was, in fact, a hotbed of disease and financial despair.

MARTINIQUE FAN *right*
1887; 7¾ x 6½ in (19.5 x 42 cm); watercolor
Decorated fans were a popular Japanese art form. Inspired by the possibilities of the shape, Edgar Degas had begun to create his own in 1869, and many of the Impressionists followed suit. Degas, Camille, Pissarro, and Gauguin used the form as an excuse for compositional innovation. Using elements from other paintings, Gauguin could present his images in a less structured fashion. Here, he simply sketches a domestic pastoral scene within the fan shape. His aim was to produce something decorative and salable.

THE PANAMA CANAL
One of the greatest engineering feats of modern times, the Panama Canal links the Atlantic and Pacific Oceans. It was begun in the late 1880s by a French company, but the project was beset with problems and the company was bankrupt by 1889. A United States company, using powerful dynamite and the latest technology, finally completed the work. It was not until 1914 that the canal was finally opened to shipping.

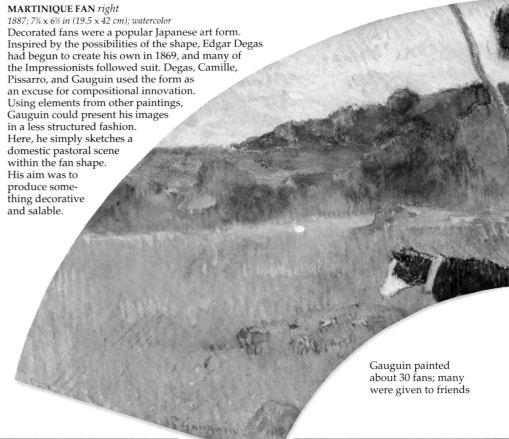

Gauguin painted about 30 fans; many were given to friends

SAINT PIERRE BAY
The steep cliffs and mountainous terrain of Martinique were inspirational for a landscape painter. The rich volcanic soil and tropical climate produced lush vegetation. However, 15 years after Gauguin's visit, the island's volcano, Mont Pelée, erupted, destroying the town of Saint Pierre and killing over 30,000 of the inhabitants.

OFFICIAL ATTITUDES
Photographs and illustrated periodicals played an important role in forming and consolidating European attitudes to the rest of the world. This page from the French newspaper *L'Illustration* presents a sanitized view of the colony. It reports the visit of Prince Alfred of England to the famous botanical gardens of Saint Pierre. Such "official" interpretations contrast markedly with Gauguin's interest in the life of the native people.

Monkeys are not indigenous to Martinique

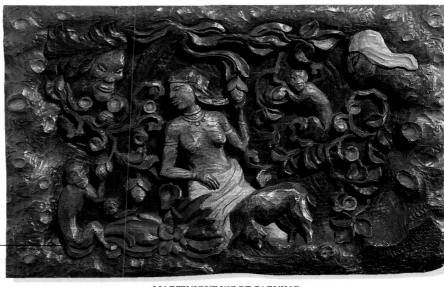

MARTINIQUE WOODCARVING
Reminiscent of Breton folk carvings (p. 34), the intricate patterning seen here can also be found on Japanese woodcarvings. The heavy, almost palpably pungent atmosphere of the subject suggests sexual freedom. This piece was probably carved later, in Brittany in 1889.

SKETCHING EASEL
Gauguin wrote, "I am taking my paints and brushes with me, and I shall immerse myself in nature far from everyone." The development of sketching easels and tubes of ready-mixed paint made working in the open air a more feasible proposition.

Sketching easel from an artists' catalog

Sketched figures bleed off the edge of the sparsely painted fan

Picking fruit

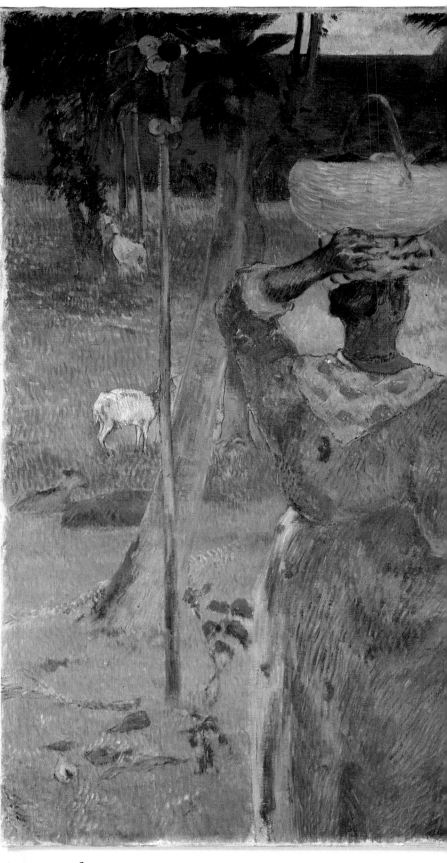

G AUGUIN PRODUCED relatively few canvases in Martinique, but the experience was significant in his development as an artist of the exotic. He had traveled to Panama and then to Martinique to renew his energies and to find inspiration. However, Gauguin was commercially minded enough to hope that his tropical scenes of Martinique would be unfamiliar, and therefore attractive, to the jaded tastes of Parisian art collectors.

A detail from a zincograph, Martinique Pastoral

MARTINIQUE SCENERY
Charles Laval; 1887; specification not available
Gauguin's influence is pronounced in this painting by his traveling companion. The decorative style and thinly applied paint are very much those of Gauguin. The composition is bizarre and seems to exaggerate the exotic subject matter.

PIGMENT BOX
This 19th-century pigment box shows the range of colors available at the time. A variety of new colors, which were both easier to handle and cheaper, were coming onto the market. Gauguin often struggled to find the money to buy paints and materials.

Among the Mangoes at Martinique

1887; 35 x 46 in (89 x 116 cm)
This painting foreshadows the great, decorative Tahiti paintings. Gauguin showed no interest in the colonialists but has exploited the colorful headdresses and the flowing robes of the Creole women.

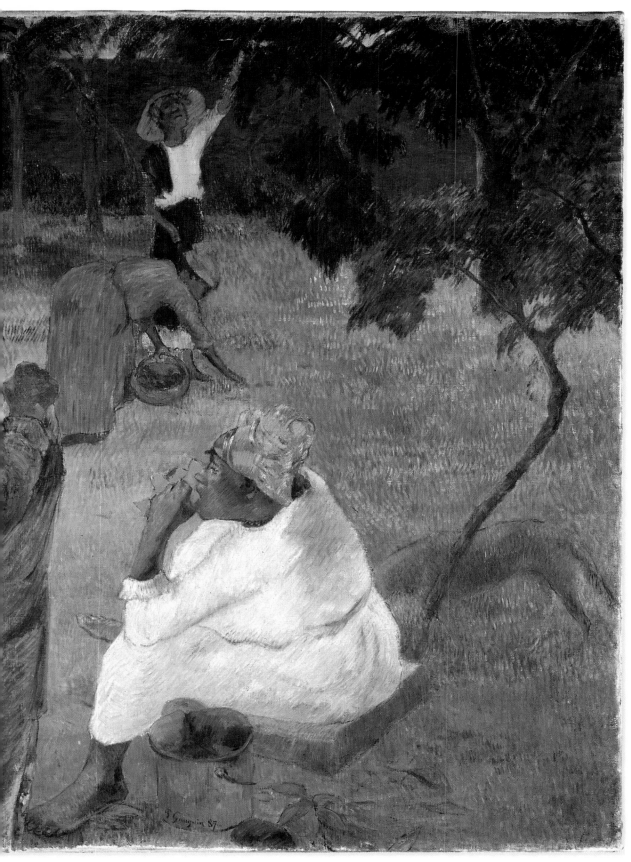

HIGH HORIZON
Gauguin often used high horizon lines, thus giving less of an impression of depth to his picture. In this painting, he was beginning to experiment with large areas of flat color, even though much of the paint is applied in obvious individual strokes.

RHYTHMS OF COLOR
The grace of the women entranced Gauguin: "What I find so bewitching are the figures, and every day here there is a continual coming and going of black women, decked out in all their colorful finery, with their endless variety of graceful movements ... carrying their loads on their heads."

CONFIDENCE IN COMPOSITION
The women's ample forms, and their confident placement across the canvas, mark this as one of the artist's most ambitious early works. The clothes of the women in the foreground have been highly worked with a considerable amount of detail.

A LETTER
In a surprisingly candid letter to his wife, Gauguin reveled in the sexual freedom of the island: "There is no lack of Potiphar's wives. Almost all of them are dark-skinned; they range from the darkest ebony to the matte white of the Maori ... and they will go as far as to cast spells on the fruit they give you in order to ensnare you...."

ARTISTS' AGENT
Theo and Vincent van Gogh were impressed with Gauguin's Martinique canvases. They especially liked this painting and bought it for their own collection, acknowledging its brave challenge to the methods of Impressionism. Theo was an art dealer and agent; this assistance proved very valuable to Gauguin.

BIRTH OF A MASTER
Octave Mirbeau, the influential critic, appreciated the significance of the Martinique paintings, as he wrote in 1891: "The series of canvases that he has brought back are dazzling and severe; in them he has finally conquered his entire personality.... From here on in Gauguin is his own master."

Tropical landscape

THE LUSH LANDSCAPE of Saint Pierre bay often appeared on postcards and illustrations of the period, and the island of Martinique supplied many of the exotic plants for the parks and gardens of France. This view, from high on a hillside, is an idealized one – the town of Saint Pierre would have been clearly visible to the artist. Gauguin has deliberately suppressed the view of the town and anything that would detract from the decorative effect; even the two huts are so camouflaged as to be almost invisible. The delicate, rhythmic brushmarks, shimmering color, and muted shadows create a harmonious ensemble, a vision of a paradise regained.

| Prussian blue | Viridian green | Chrome oxide green |
| Chrome orange | Naples yellow | Lead white |

ARTIST'S PALETTE
Gauguin has drawn an outline in diluted Prussian blue over the painting's thin buff ground. Broad brushstrokes are used to fill in the outline, particularly at the edges of the painting.

Tropical Vegetation

1887; 45¾ x 35 in (116 x 89 cm)

Looking at Gauguin's Martinique canvases makes sense of his quirky suggestion that he was developing the rapid, spontaneous brush strokes of Impressionist painting to create the effect of a richly worked tapestry. The island was idyllic for a landscape painter, as Gauguin described to his friend Emile Schuffenecker: "Below us the sea ... and on either side of us there are coconut trees that are perfect for the landscape painter." Octave Mirbeau, the critic, inspired by the canvases, wrote of the "divine, Eden-like abundance in these jungle scenes, with their monstrous vegetation and flowers."

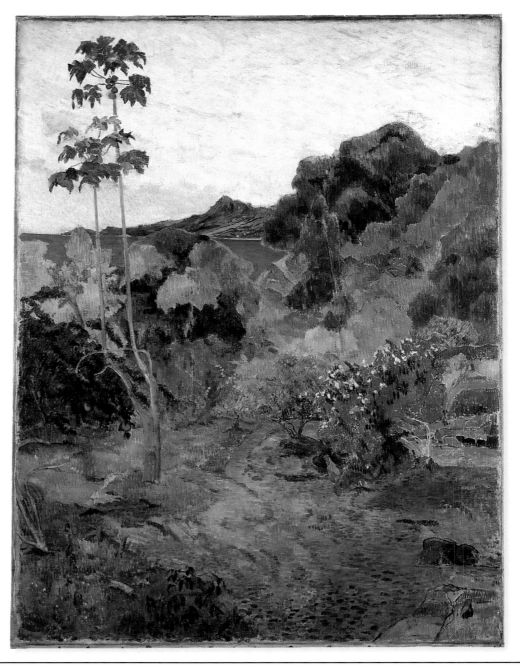

CANVAS STRETCHER
The crude construction of the original stretcher suggests that Gauguin probably made the lightweight support himself, from boxwood. Unusually, he used a canvas with a fine regular weave that was commercially available.

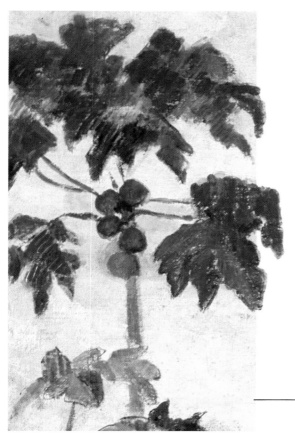

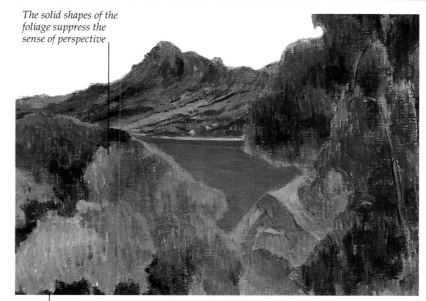

AMBIGUOUS SPACE
Hidden among the foliage are two buildings that, when registered by the viewer, confuse the scale and perspective of the painting. The roof of one appears in the bottom corner of this detail.

FRUIT AND FOLIAGE
A papaya tree breaks the skyline. Its fruit and foliage echo the subtle gradations of green and orange elsewhere in the painting. Emulating Cézanne, Gauguin uses pure colors to create a strong sense of spontaneity and movement.

THE LAUREL BUSH
Here the flowers are pushed forward by the juxtaposition of light and dark strokes. In a landscape distinguished by its decorative effect, this is one of the few carefully delineated areas.

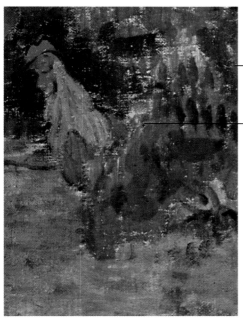

Simple strokes of vermilion highlight the rooster in the foliage

ANIMAL LIFE
A close examination of the canvas reveals a rooster, partially obscured by a laurel bush. Camouflaged in the dense clustering of flora that evokes the oppressive heat of the tropical landscape, the rooster gives a sense of scale to the composition.

Traces of the preparatory blue outline remain

ABSTRACT EFFECT
Some of Gauguin's brushmarks are indecipherable and almost deliberately ambiguous. The detail (left) apparently bears his signature and the date of the painting, but the marks are not clearly discernible. The loose brushwork and abstract shapes contrast markedly with the highly worked parts of the canvas.

The artists in Pont-Aven

B ̣Y EARLY FEBRUARY 1888, Gauguin was once more in Brittany, staying at the Pension Gloanec. Theo van Gogh's support had given him a new sense of confidence in his work. All that was needed, he wrote, was to make a "supreme effort." His recent experiences in Martinique had broadened his vision and enabled him to develop a more original and less picturesque interpretation of the Breton scene. Gauguin wrote that one of his canvases was "absolutely Japanese, by a savage from Peru." The artist was now forty years old, his family life had fallen apart, and he still had his artistic reputation to consolidate. He was suffering from dysentery and the ill effects of his sustained consumption of absinthe.

A FAMILY PHOTOGRAPH
Gauguin had little contact with his family after his decision to become an artist. This is a rare photograph showing Gauguin, wearing a Breton collar, with his children Aline and Emil.

BRETON JACKET
Gauguin always prided himself on his distinctive appearance. In a number of photographs (above right), he wears a finely worked Breton collar apparently sewn onto a corduroy jacket. As with the carving of domestic furniture (p.34), there was a Breton tradition of decorating their clothing.

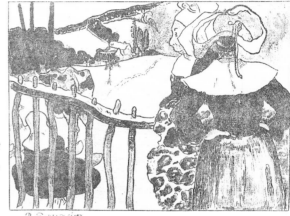

BRETON WOMEN BY THE FENCE
Determined to create something new, rather than merely reporting on peasant life, Gauguin made simple zincographs, as shown above, playing on the stylistic effect of the black curved outlines.

THE ARTISTS' COMMUNITY
This view looking across Pont-Aven shows it to be an orderly little town nestled in a wooded valley. It is very close to the sea, and the town itself has a small port and a number of working watermills.

PARIS CONNECTIONS
When the young Emile Bernard arrived in Pont-Aven in August 1888, he wrote to Vincent van Gogh: "[Gauguin] is so great an artist that I am almost afraid of him."

The window of Gauguin's studio

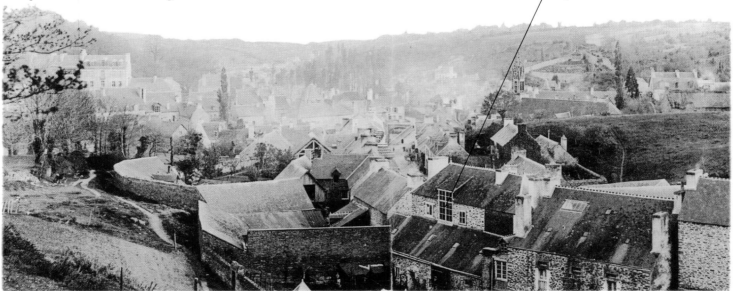

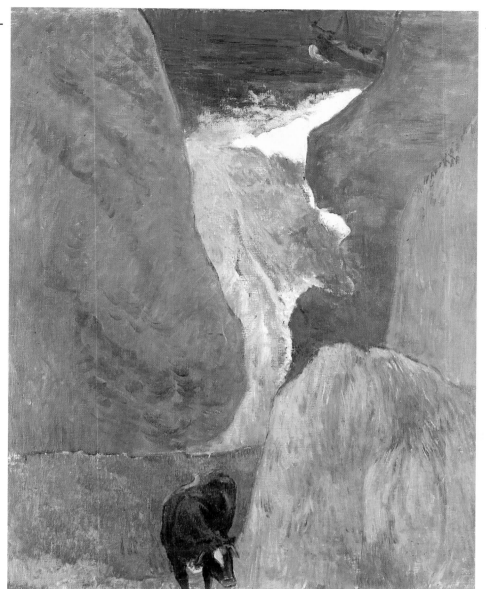

SEASCAPE WITH COW
1888; 28¾ x 23½ in (73 x 60 cm)
Gauguin used bold blocks of color framed within dark outlines. The bird's-eye view owes something to Japanese prints, but is also true to the dramatic Brittany coastline. A very earth-bound cow looks out of the foreground while a little boat skids away across the top of the painting.

THE TALISMAN
Paul Sérusier; 1888; 10½ x 8 in (27 x 21 cm)
This sketch of the Bois d'Amour at Pont-Aven is the result of a well-documented painting lesson. Sérusier painted the picture on a small block of wood with Gauguin at his side instructing: "How do you see these trees? They are yellow. Well then, put down yellow. And that shadow is rather blue. So render it with pure ultramarine." Its title refers to its magical status among young artists of the time.

Artists of the abstract

Charles Laval, Paul Sérusier, Emile Bernard, and Gauguin had all gathered in Pont-Aven by August 1888, and were developing the principle Gauguin had outlined in a letter to Vincent van Gogh: "Art is an abstraction...."

BATHERS AT ASNIERES
Georges Seurat; 1883–84; 79 x 118 in (201 x 300 cm)
Seurat's paintings were electrifying Paris. Gauguin was never comfortable with either the young painter or his scientific method of painting. Seurat's main subject was the new pastimes of the workers of Paris; Gauguin, in obvious contrast, concentrated on rural themes.

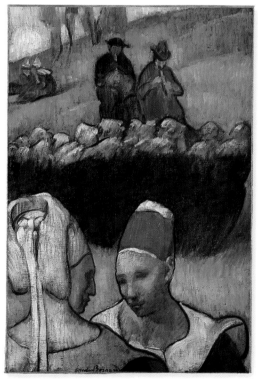

BRETON STUDY
Emile Bernard; c.1888; 32 x 21¼ in (81 x 51 cm)
Emile Bernard, like Gauguin, was searching for a simpler style of painting. His interest in Japanese prints, stained glass windows, and medieval art led him to a style of bold colors, simple shapes, and strong contour lines. Bernard's cloissonné style was appropriated and transformed by Gauguin.

A new vision

JAPANESE INFLUENCE
The tree dividing Gauguin's painting was inspired by Hiroshige's dramatic branch.

"THIS YEAR I have sacrificed everything – execution, color – for style, because I wished to force myself into doing something other than what I know how to do." Gauguin wrote this shortly after completing his painting, *The Vision after the Sermon*. This work marks his final break with the Impressionists, and the beginning of a new style in painting that became known as Symbolism. Gauguin believed that art should be concerned with the inner meaning of the subjects painted, not with their obvious outward appearance. To achieve this, he began to simplify color and line, as in this painting. The artist offered *The Vision after the Sermon* to the local church at Nizon, feeling that this would be the right setting for it, surrounded by "bare stone and stained glass ... it would look out of place in a salon." His offer was flatly refused.

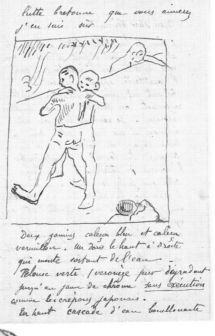

LETTER TO VAN GOGH
This letter to Vincent van Gogh, from July 1888, contains the initial sketch for a painting entitled *Children Wrestling*, completed a month before *The Vision after the Sermon*. Wrestling was a popular sport in Brittany. The sketch illustrates how Gauguin was experimenting with space, placing the figures in a landscape divided by the line of the riverbank. His striving for a non-naturalistic style is clear.

DYNAMIC WRESTLERS
Gauguin was inspired by a series of studies of wrestlers produced by the Japanese artist Katsushika Hokusai (left). His work, full of movement and energy, was familiar to French artists. Gauguin's wrestlers echo the dynamic pose of Hokusai's.

The Vision after the Sermon

1888; 28¾ x 36¼ in (73 x 92 cm)
In this canvas, a group of pious women experience a communal vision of Jacob wrestling with a mysterious angel. Based on a biblical passage from the book of Genesis (32: 23-31), the meaning is ambiguous – is the struggle a moral test, a fight between good and evil, or a battle against God or Satan? When exhibited in 1889, it was seen as a studied attempt to provoke shock and outrage.

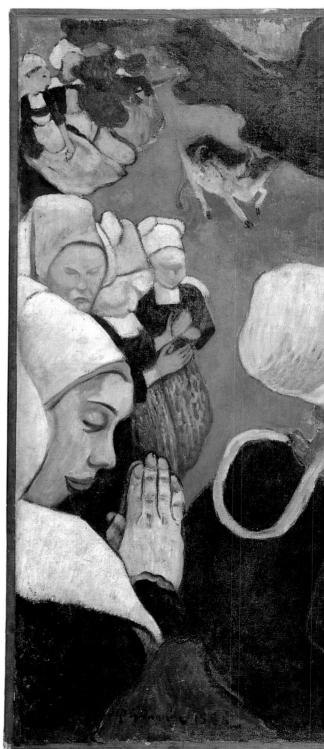

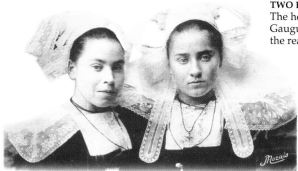

TWO BRETON WOMEN
The headdresses painted by
Gauguin are simply outlines of
the real traditional costume (left).

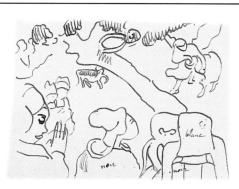

PRELIMINARY SKETCH
This sketch appears in a letter to
van Gogh from September 1888.
Gauguin labels his sketch and lists
the colors used: "ultramarine blue,
bottle green, number one chrome
yellow; angel's hair, number two
chrome; feet, flesh orange."

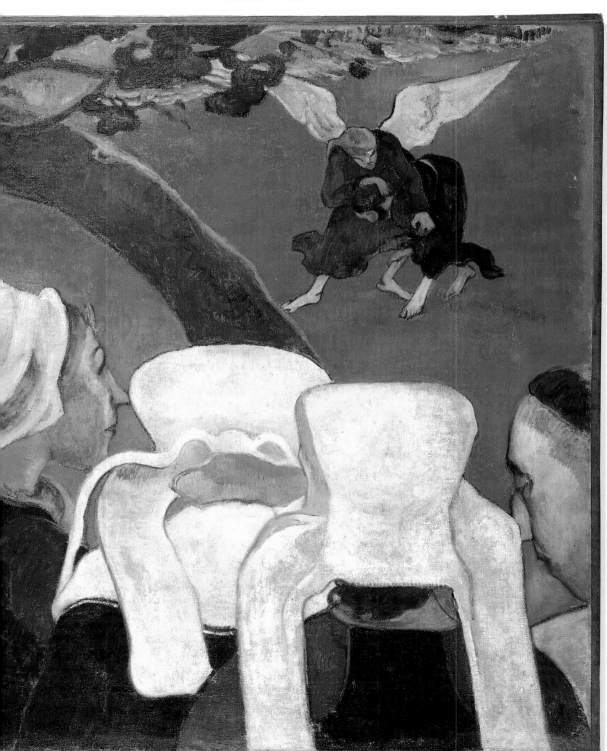

THE ARTIST'S STRUGGLE
Gauguin gives his own
interpretation of the
struggle between the man
and angel: "For me in
this painting, the land-
scape and the fight only
exist in the imagination
of the people praying after
the sermon, which is why
there is a contrast between
the people, who are
natural, and the struggle,
going on in a landscape
which is non-natural and
out of proportion."

MYSTICAL LANDSCAPE
To express the mystical
nature of this encounter,
Gauguin has used a very
simple idea: the grass
of the physical world is
green; the grass of this
transformed landscape
is vermilion red.

FLAT COLOR
Gauguin's use of
flat areas of pure color
confounds traditional
notions of perspective.
The use of blue-black
outlines heightens the
intensity of the colors.

ROLE OF THE PRIEST
It seems that the
priest is included in the
painting because, like the
visionary artist, he is the
means by which people
can look beyond the reality
of the everyday world.

RELIGIOUS CLOTHING
The dark clothes and
the white headdresses of
the women are reminiscent
of those of a religious order,
emphasizing that they are
simple, faithful people.
Gauguin wrote, "I believe
I have attained in these
figures a great rustic and
superstitious simplicity.
It is all very severe...."

Life with van Gogh

THE FEW MONTHS THAT Gauguin and Vincent van Gogh lived together were to prove a traumatic but fruitful experience for both artists. In desperate need of someone to promote his art, Gauguin had turned to Vincent van Gogh's brother Theo, an art dealer. In May 1888, Vincent invited Gauguin to join him in Arles, aiming to set up a studio in the South. Spurred on by Theo's offer of financial support, Gauguin eventually agreed to the proposal. On arriving in October, he joined Vincent and remained there for just under three months. Gauguin was stubborn and arrogant, van Gogh was passionate and ill: the two men learned a great deal from each other, but were often at loggerheads. Events came to a head when, on the evening of December 23, van Gogh threatened Gauguin with a razor. Later that evening, suffering great remorse, Vincent cut off part of his own ear, presented it to a local prostitute, and almost bled to death as a consequence. On finding him, Gauguin contacted Theo; he then returned to Paris as quickly as he could.

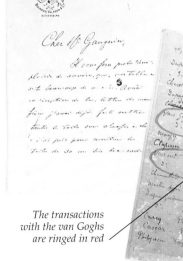

A formal letter to *"Monsieur Gauguin"* from Theo van Gogh

The transactions with the van Goghs are ringed in red

THEO VAN GOGH
Theo was managing to sell a number of Gauguin's works at Boussod and Valadon, and therefore had considerable influence over Gauguin.

TAKING ACCOUNT
Gauguin was always businesslike in his affairs. This page from his notebook has a list of exchanges and sales, some to prominent names, including Edgar Degas and Mary Cassatt. He was appalled by Vincent's untidiness and tried, unsuccessfully, to bring some order to his affairs.

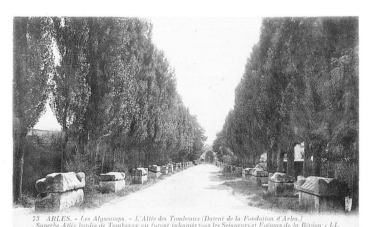

73 ARLES. - Les Alyscamps. - L'Allée des Tombeaux (Datent de la Fondation d'Arles.)
Superbe Allée bordée de Tombeaux où furent inhumés tous les Seigneurs et Evéques de la Région.- I.L.

ANCIENT CEMETERY
This postcard shows the Alyscamps, the ancient cemetery of Arles that dated from Roman times. Gauguin and van Gogh painted here, but both played down the antiquarian aspect in their paintings.

THE ALYSCAMPS
1888; 36¼ x 28¾ in (92 x 73 cm)
The Alyscamps (left) was the first of various subjects to be tackled by both artists, as they explored the autumnal colors of Arles. Three women make their way down an aisle of poplars. The colors are arbitrary and brilliant, but while van Gogh used thick brushwork (p. 25), Gauguin applied the paint thinly.

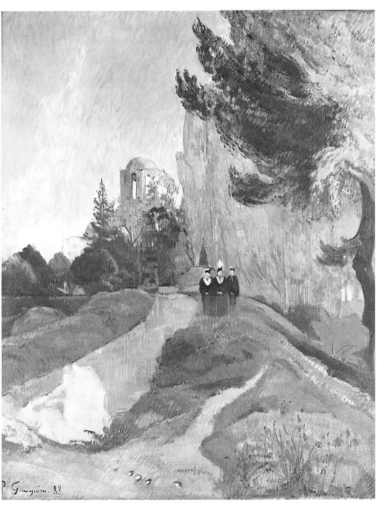

AT THE CAFE

1888; 28 x 36¼ in (72 x 92 cm)

The setting is the Café de la Gare, where van Gogh had stayed in his early days at Arles. The proprietress, Madame Ginoux, leans on the marble-topped table with a wry smile on her lips. The café interior and its owner were the subject of several of van Gogh's most expressive canvases.

Consciously or otherwise, Gauguin made this painting his homage to van Gogh. It features three of van Gogh's best-known models: Madame Ginoux herself, the Zouave (on the far left), and the postman, Joseph Roulin, who sits chatting at a table with three prostitutes. The same colors are used in Gauguin's stylized work as in Vincent's brooding *Night Café* – red, green, and ochre. Van Gogh said he had wanted to show the "terrible passions of humanity," whereas Gauguin's work is much more detached.

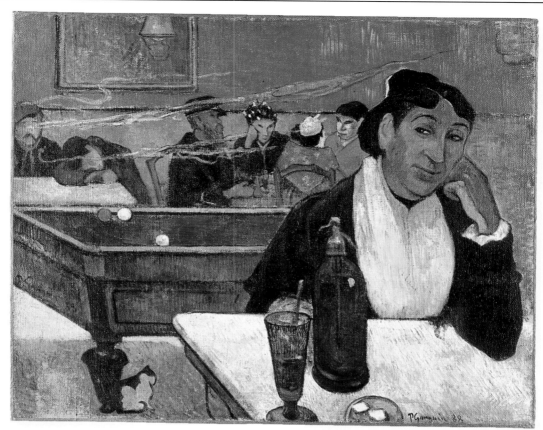

The red lines suggest this was originally an accounts book

MADAME GINOUX
The enigmatic smile of Madame Ginoux, sketched here, is repeated in the painting.

THE YELLOW HOUSE

Vincent van Gogh; 1888; 28 x 36 in (72 x 91.5 cm)

Van Gogh lived in the house on the right with the green doors and shutters. He painted his house the color of the sun and was overjoyed at the prospect of being joined there by *"le maitre"* ("the master"), as he called Gauguin. Their habits and ideas of art were quite different, although Gauguin learned much from his companion's brilliant use of color.

PROSTITUTE SKETCHES
Gauguin and van Gogh were frequent visitors to the brothels in Arles. For Gauguin, drinking and womanizing were necessary fuels to his creative life. Van Gogh described Gauguin as a man in whom "blood and sex prevail over ambition." The woman drawn here by Gauguin does not appear in any of his paintings.

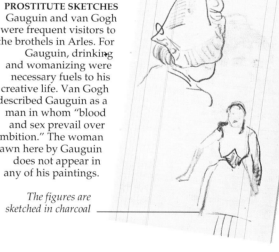

The figures are sketched in charcoal

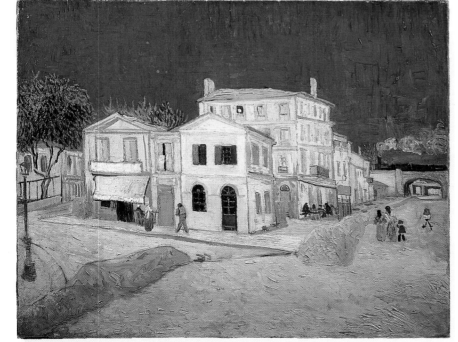

ROMAN REMAINS
The huge Roman amphitheater that dominates the town center was one of Arles' major attractions. However, the historical remains apparently held no interest for the two artists.

Portraits of the artist

FEELING ISOLATED IN ARLES, in the spring of 1888, van Gogh had suggested to Gauguin and Emile Bernard that they paint portraits of one another for him. In fact, they both painted self-portraits but included a sketch of the other artist in the background.

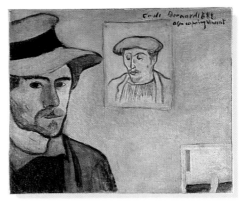

SELF-PORTRAIT
Emile Bernard; 1888; 18 x 21½ in (46 x 55 cm) When asked by van Gogh to paint Gauguin, Bernard wrote back, "O, to do Gauguin, impossible." However, the sketch of Gauguin is central to the composition, while Bernard stands modestly to one side. The top of a Japanese print is just visible.

Les Misérables

1888; 17¾ x 21½ in (45 x 55 cm) "In matters of art I am always right!" This dramatic self-portrait declares Gauguin's new-found confidence. Subtitled *Self-portrait with Portrait of Bernard*, he described this unsettling painting to van Gogh by relating it to the popular novel by Victor Hugo, *Les Misérables*. He identified himself with its outcast hero: "And Jean Valjean, whom society oppresses, an outlaw, with his love, his strength – is this not also the image of the present-day Impressionist? By painting him in my own likeness you have an image of myself, as well as of us all, poor victims of this society." In fact, van Gogh preferred the honesty of Bernard's painting.

THE ABSTRACT ARTIST
Gauguin adored the abstraction of this painting, describing it as "so abstract as to be incomprehensible." He likened the decorative features of the face to flowers on a Persian carpet.

UNNATURAL HUES
The colors Gauguin used for this painting are deliberately unnatural. The artist's face glows with fiery red, evoking the great artistic struggle within. Gauguin hints at the intense burning and suffering of creativity in a letter written to his close friend Emile Schuffenecker of October 8, 1888: "Imagine something reminiscent of pottery being baked in a kiln. What reds, what violets! And the eyes blazing away like flames from a furnace!"

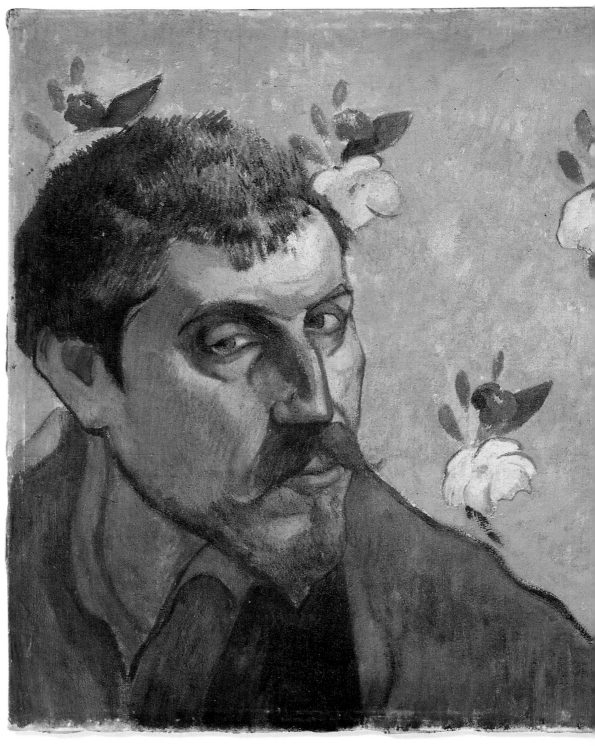

Portrait of van Gogh Painting Sunflowers

1888; 28¾ x 36 in (73 x 91 cm)

Gauguin shows van Gogh painting one of his many versions of the sunflowers. They were painted to decorate Gauguin's bedroom in Arles, and Gauguin admired them the most of all van Gogh's work. Van Gogh is shown painting directly from his subject, a vase of sunflowers. In this respect, his way of working differed from that of Gauguin, who preferred to paint from imagination.

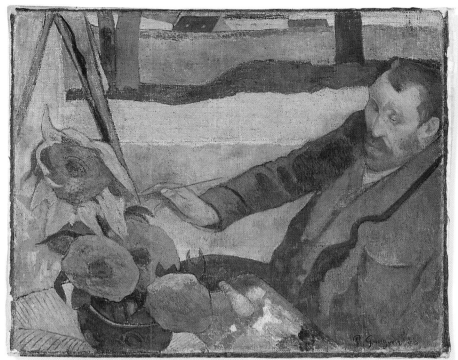

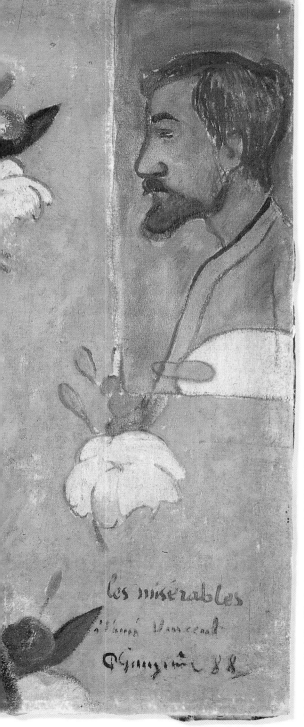

ARTISTIC TENSION
The artist is viewed from above, so emphasizing the act of painting. The awkward tension created by the cramping of the figure was appreciated by a strained van Gogh: "It really is me, very tired ... as I was at the time."

THE ARTIST AT WORK
The painting (above) may have developed from this sketch in Gauguin's notebook. It is a unique record – it shows van Gogh in the process of painting, the hint of a smile on his lips.

PAINTING PORTRAITS
A portrait of Emile Bernard hangs on the wall; it is, in fact, little more than a sketch. Bernard's thumb is wrapped awkwardly around a palette. Enclosing a painting within a painting was a common practice among avant-garde artists.

SIMPLE BACKDROP
The simple, decorative wallpaper provides a calm, unassuming backdrop to the intensity of Gauguin's self-image. The wallpaper symbolized the artistic honesty and simplicity of the Impressionists. The painting is dedicated "*à l'ami Vincent*," and van Gogh, although delighted by the gift, was distressed by the tortured expression of the artist. He hoped that a spell in the South would revive Gauguin's spirits.

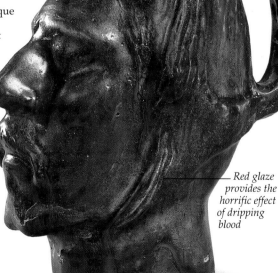

— Red glaze provides the horrific effect of dripping blood

JUG IN THE FORM OF A HEAD
A few days after discovering van Gogh covered in blood, Gauguin witnessed a public guillotining in Paris. This pot with Gauguin's own features was created soon after these experiences. Severed heads were a popular subject, and this clearly shows the artist as martyr.

The Universal Exhibition

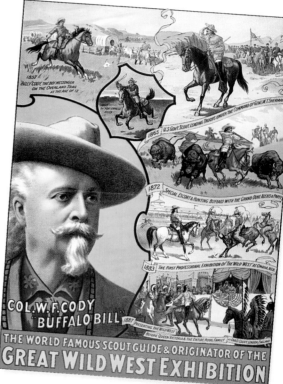

THE UNIVERSAL EXHIBITION OF 1889 was held in Paris to celebrate the centenary of the French Revolution, and to advertise the country's recovery from its recent political humiliation in the Franco-Prussian War. Aiming to place France firmly at the forefront of the worlds of culture, politics, and technology, the exhibition consisted of the very best that France could produce. Refused a place in the official art exhibition, Gauguin took over from Schuffenecker the organization of an independent exhibition at the Café des Arts, adjacent to the exhibition area. The exotic nature of the colonial exhibits strengthened Gauguin's resolve to leave Europe for some tropical paradise where he could live cheaply, enjoy a good life, and produce marketable works of high quality. He considered a number of different places.

WORLDLY SUCCESS
The Eiffel Tower was completed for the opening of the Universal Exhibition. Gauguin enthused about this "triumph of iron."

Reproduced in the catalog is one of Gauguin's zincographs, for sale at the exhibition

IMPRESSIONIST AND SYNTHETIST
The title of the independent exhibition, *"Impressionniste et Synthétiste,"* was deliberately chosen to mark the distance between Gauguin and his fellow exhibitors (Emile Bernard, Charles Laval, and others) and the Impressionists. Gauguin and Bernard dominated the show, which, although financially unsuccessful, had a powerful effect on fellow artists and writers. This small illustrated catalog helped publicize their work.

BUFFALO BILL
Buffalo Bill traveled extensively through Europe, staging his exciting Wild West show. He performed at the Universal Exhibition, and Gauguin went to see his show on more than one occasion. He was attracted by the flamboyant character of Buffalo Bill, a half-savage, half-civilized man of action.

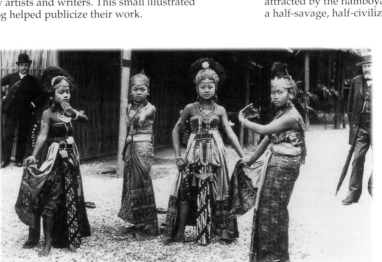

JAVANESE DANCERS
One of the most popular features of the exhibition was the Javanese dancers, epitomizing the most extravagant fantasies of the Europeans visiting the show. Gauguin's active imagination was fired by the colonial displays, and he considered emigrating to Tonkin (Vietnam), Madagascar, and Tahiti.

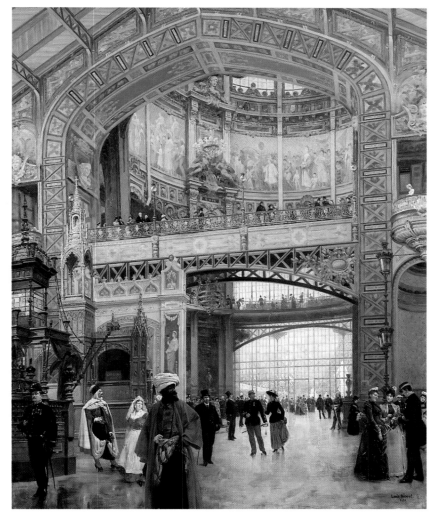

INSIDE THE EXHIBITION
The exhibition was a very lavish and cosmopolitan event. People came from all over the world both to take part and to view the wonders on display. Special pavilions were built to house all the exhibits.

HUMAN MISERY
This zincograph is one of a set based on Gauguin's earlier paintings. It was "available on request" at the Café des Arts show. The crouching figure relates directly to the Peruvian mummy (right).

PERUVIAN MUMMY
Gauguin was intrigued by this Peruvian crouching mummy on display at the Ethnographical Museum, in Paris. He sketched it, and used the pose of the dead figure in a number of canvases.

Gauguin used this pose to represent suffering and despair

Eating or drinking vessel

c. 1889-91; 9½ x 6 x 2 in (24.5 x 15 x 5.5 cm)
The bowl is sensitively carved to cradle neatly in the holder's hand. The body of the bowl is cut away, leaving the forms standing in low relief. The activities depicted are highly ambiguous, but the poses suggest adoration and life-giving forces. The crudity of the carving can be seen as a rejection of some of the "civilized" excesses evident at the exhibition.

A woman's head and suggestions of her body

A flower, symbol of life and regeneration

The asymmetry of the bowl emphasizes the organic nature of the wood from which it has been carved

The interior of the bowl is faceted to catch the light

The imagery is stained to differentiate it from the dark golden color of the polished wood

Staying with Schuffenecker

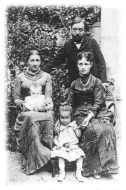

The Schuffenecker family

D<small>URING HIS STAY IN</small> P<small>ARIS</small> in 1889, Gauguin lodged in the studio of his friend Emile Schuffenecker. They had been friends since 1872, when they both worked for the exchange agency Banque Bertin. Schuffenecker had encouraged Gauguin to pursue his interest in art – he accompanied him on visits to the museums and galleries of Paris, and set Gauguin an example by giving up his job to paint. His affluent family connections allowed him to give Gauguin financial help. Despite Schuffenecker's support, Gauguin undertook this group portrait, which gives an unsympathetic view of the relationship between *"le bon Schuff"* and his wife. It was Schuffenecker, along with Gauguin and Emile Bernard, who developed the style of synthetism. Schuffenecker introduced Gauguin to Daniel de Montfried, who was to play a significant role in Gauguin's career.

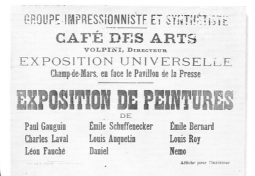

GROUPE IMPRESSIONNISTE ET SYNTHÉTISTE

CAFÉ DES ARTS
VOLPINI, D<small>IRECTEUR</small>

EXPOSITION UNIVERSELLE
Champ-de-Mars, en face le Pavillon de la Presse

EXPOSITION DE PEINTURES
DE

Paul Gauguin	Émile Schuffenecker	Émile Bernard
Charles Laval	Louis Anquetin	Louis Roy
Léon Fauché	Daniel	Nemo

Affiche pour l'intérieur

The serenity of expression in this early portrayal contrasts with her later weariness

A plaster bust

INDEPENDENT EXHIBITION
It was Schuffenecker who was the instigator of the independent exhibition at the Café des Arts (pp. 28–29). It was an opportunity for a younger generation of artists, including Maurice Denis and Pierre Bonnard, to see the works of Gauguin and his circle.

BUST OF MADAME SCHUFFENECKER
This sympathetic portrayal of the young Madame Schuffenecker was produced on the occasion of the Schuffeneckers' marriage in 1880. Gauguin's persistent attempts to seduce his friend's wife led to a breakdown of their friendship – Gauguin, isolated from his own family, had treated the household as if it were his own.

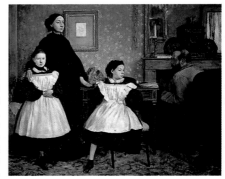

THE FAMILY BELLELLI
Edgar Degas; 1858–67; 79 x 98 in (200 x 250 cm)
Gauguin visited Edgar Degas' studio in the early months of 1889 – the artists admired each other's work greatly. The power of the Schuffenecker portrait seems to owe much to Degas' *The Family Bellelli*, painted almost 30 years earlier. The Degas canvas is more than twice the size of Gauguin's painting.

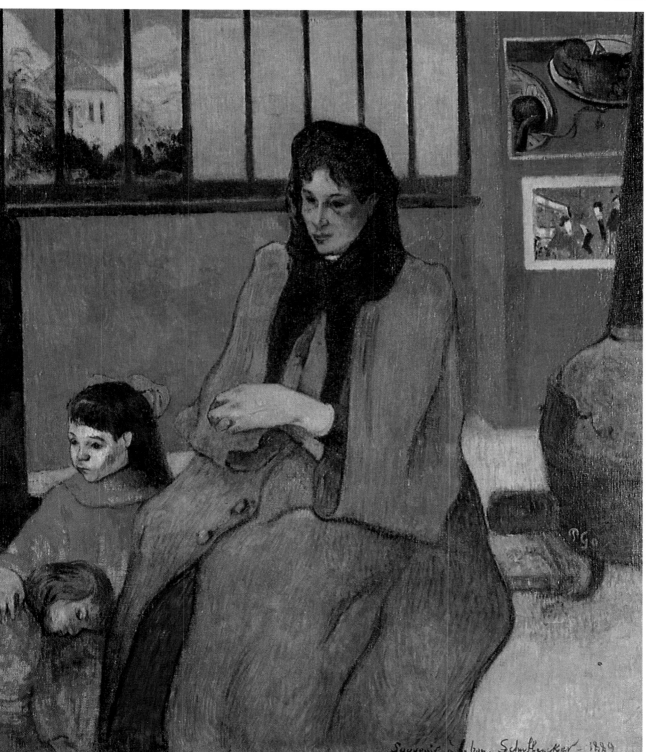

A photograph of the Gauguin children, sent "To my dear Schuffenecker" by Mette Gauguin

The Family Schuffenecker

1889; 29 x 36 in (73 x 92 cm)

In his letters, Gauguin variously described Madame Schuffenecker as a shrew, a harpy, and a limpet. The family was probably very uneasy with the unsympathetic nature of Gauguin's depiction of them. Emile's subservient attitude is set against the icy, brooding presence of his wife, whose odd, clawlike hands and strange silhouette add to the tension evident in the composition. The canvas was never exhibited in their lifetimes.

BEGGING LETTER
Gauguin was an industrious correspondent, writing regularly to his family, friends, and other artists. This letter to *"Mon cher Schuff"* reveals Gauguin's reliance on his fellow painter. He writes despairingly, "I still have my money problems, when will it all end? I am so impatient for the Charlopin order to be finished so at last I may live in a place where money is not needed."

A solemn portrait

AS INSCRUTABLE AS THE MONA LISA, the primary source, mood, and pose of Gauguin's portrait of Madame Satre seems to have been Edgar Degas' copy of Hans Holbein's painting *Anne of Cleves*, dated 1539. The awkward, formal composition of Gauguin's painting is a rejection of the Impressionists' desire to capture an immediate visual impression in their work. Theo van Gogh was one of the few who appreciated its originality – he wrote of it: "The woman looks a bit like a heifer, but there is something so fresh and rural about it that it is a pleasure to behold." The painting is, in fact, a very complicated blend of Pre-Columbian, Japanese, and European art, with elements of folk and popular traditions.

Red ochre Vermilion Cadmium yellow

Prussian blue Cobalt blue Emerald green

ARTIST'S PALETTE
Gauguin used an extremely limited color range to great effect. He based his work on variants of the primary colors of red, yellow, and blue. The simplicity of color enhances the definition of the striking composition.

La Belle Angèle

1889; 36¼ x 28¾ in (92 x 73 cm)
Marie-Angèlique Satre was one of the beauties of Pont-Aven. Gauguin painted this as a present for her parents, who kept an inn near the Pension Gloanec. The sitter responded in horror to the daring composition, and the gift was rejected outright.

PROBLEMS WITH PIGMENTS
The artist's palette was altered drastically by scientific and chemical developments in the 19th century. Blue pigments had been particularly problematic; the most desirable was ultramarine, produced from semiprecious stone, lapis lazuli. However, as the 19th-century pigment box (above) from the paint maker Lefranc shows, a whole new range of blues was becoming available.

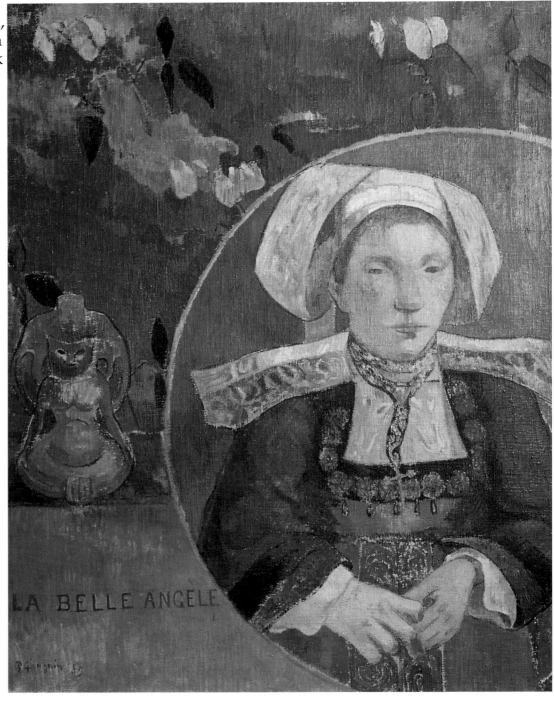

LA BELLE ANGELE

MULTICOLORED FACE

Gauguin used the coarse weave of the canvas to great effect. He normally painted thinly to allow the texture of the canvas to impart a visible rhythmic pattern to the picture surface. However, this detail of the face shows that it has been intensively overpainted, using a number of different colors, to build up the facial features.

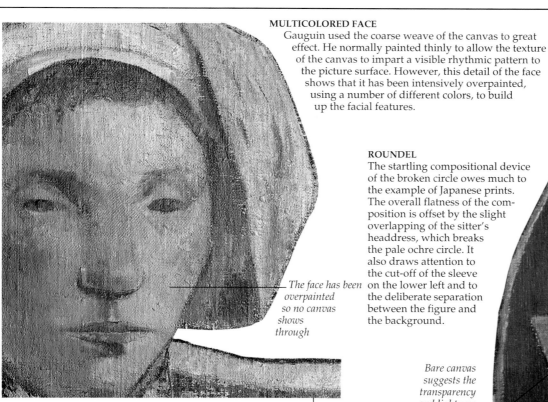

ROUNDEL

The startling compositional device of the broken circle owes much to the example of Japanese prints. The overall flatness of the composition is offset by the slight overlapping of the sitter's headdress, which breaks the pale ochre circle. It also draws attention to the cut-off of the sleeve on the lower left and to the deliberate separation between the figure and the background.

The face has been overpainted so no canvas shows through

Bare canvas suggests the transparency and lightness of the lace epaulets

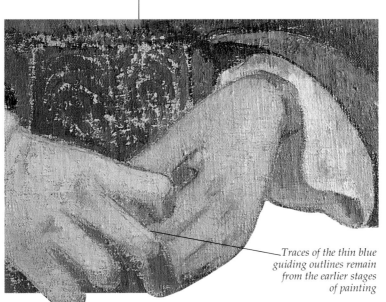

An outline of bare canvas and ochre

The black clothes emphasize the figure's depiction in a separated space

PERUVIAN IDOL

The facial features of the Peruvian idol balance those of "the beautiful angel," highlighting the difference between the strange pagan presence and the devout Bretonne.

BROAD OUTLINE

An x-ray film of the canvas shows Gauguin's earlier underdrawing of preliminary lines. A network tracery of thin blue lines painted in very diluted oil paint created a basis for his portrait. These were then "filled in" with dragged brushstrokes of undiluted paint. By changing their direction, he has created a decorative effect and given an impression of texture.

CAREFUL LETTERING

The writing floats on the painting's surface, indicating the non-naturalistic nature of the pictorial space. Carefully placed between two guiding lines, it is painted in blue and highlighted by contrasting yellow and red.

Traces of the thin blue guiding outlines remain from the earlier stages of painting

Le Pouldu

To GAUGUIN IT WAS CLEAR that his Parisian audience was not sympathetic to his work, and he had enjoyed no real financial success. To escape the scorn of the Paris art world, he sought solace at Le Pouldu in Brittany, where he knew he would be surrounded by admiring followers. From there he wrote bitterly to Emile Bernard: "Of all my struggles this year, nothing remains save the jeers of Paris; even here I can hear them, and I am so discouraged that I no longer dare to paint." Le Pouldu is a small port 9 miles (15 km) from Pont-Aven, on the rugged south Brittany coast. Gauguin stayed there with his circle of devotees: Charles Laval, Meyer de Haan, Paul Sérusier, Charles Filiger, and others. Many of the group lodged at Marie Henry's inn, *La Buvette de la Plage*, which became their headquarters. Together they decorated the inn's main areas. Meyer de Haan, a Dutch artist, came from a wealthy family and gave financial support to the small community of artists. De Haan's interest in esoteric literature fascinated Gauguin, who often depicted him (p. 61).

NEIGHBORING FARM
This farm provided Marie Henry's inn with milk and eggs. It was painted by both Gauguin and de Haan.

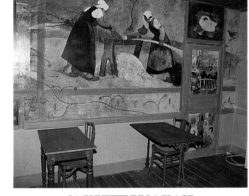

LA BUVETTE DE LA PLAGE
The dining room of Marie Henry's inn, originally decorated by the community of artists who lodged there, has recently been restored. These panels were painted by Gauguin.

Artist's hand-colored design

CARVED FURNITURE
Brittany has a strong tradition of folk carving; Gauguin was attracted to objects such as this *lit-clos* (carved bed). The Breton folk-artist's use of obscure symbols, designs, and lettering was particularly unusual. The heavy and simple shapes are reinterpreted in Gauguin's work.

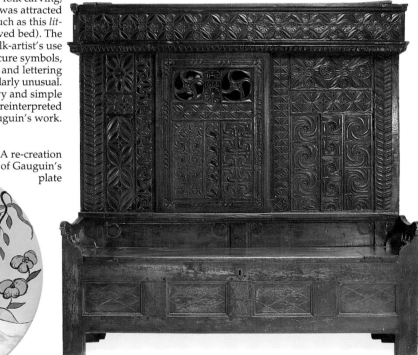

A re-creation of Gauguin's plate

DESIGN FOR A PLATE
This pretty transfer design for a plate, with its well-known motto, "Evil be to him who evil thinks," seems to be purely decorative. The image of the goose girl deliberately recalls the erotic Greek legend of Leda and the Swan.

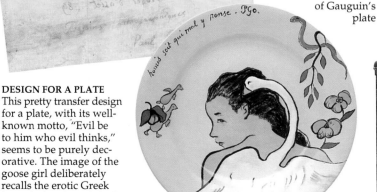

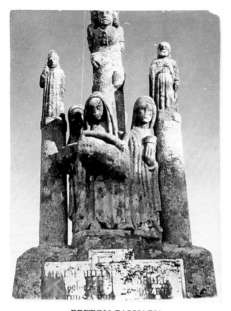

BRETON CALVARY
This sandstone calvary of the three Marys supporting the body of Christ stands in the nearby village of Nizon. The religious significance, scale, and decorative power of these large brooding monuments were a great source of inspiration to Gauguin.

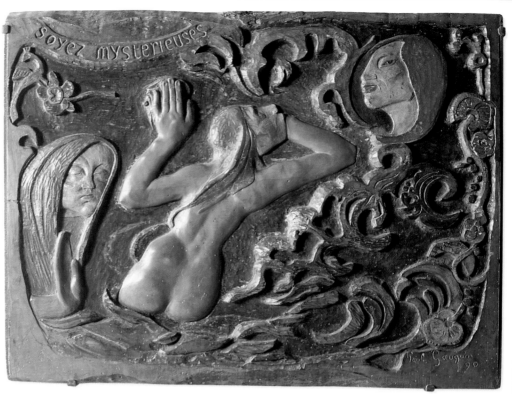

BE MYSTERIOUS
1890; 29¼ x 37½ in (73 x 95 cm)
Gauguin considered this a very successful piece of work. It was carved as a partner to an earlier wood panel, entitled *Be in Love and You Will be Happy*. This panel is deliberately ambiguous and lacks the obvious symbolism of the earlier piece. Even before his trip to the South Seas, Gauguin was transposing his Breton themes to an imaginary exotic setting. Before leaving for Tahiti, Gauguin priced all of his work in the hope that it would sell while he was away. Interestingly, he priced this wood carving at three times the price of his most expensive painting.

Gauguin's notes on the meaning of the composition

Very rough sketch of a tree

CHRIST IN THE GARDEN OF OLIVES, SELF-PORTRAIT
1889; 28¾ x 36¼ in (73 x 92 cm)
The red hair fooled no one. Gauguin had once again given his own distinctive features to Christ, this time in the Garden of Olives, awaiting his inevitable betrayal. As with so much of his work he felt that "this canvas is fated to be misunderstood," and he attempted to explain it to his critics: "There I have painted my own portrait.... But it also represents the crushing of an ideal, and a pain that is both divine and human. Jesus is totally abandoned; his disciples are leaving him, in a setting as sad as his soul."

Paul Gauguin
ARTISTE-PEINTRE

VISITING CARDS
It is not possible to tell whether these notes are an *aide-memoire* for Gauguin himself or an attempt to describe *Christ in the Garden of Olives* to someone else. Gauguin was always anxious to keep friends informed of his work.

The suffering artist

An ARTICLE WRITTEN IN MARCH 1891, by Albert Aurier, the Symbolist critic, proclaimed Gauguin as the figurehead of modern painting. The previous few years had been highly productive for Gauguin: he had a committed school of admirers in Brittany and had taken part in some highly publicized, although not financially successful, exhibitions in Paris. However, he was deeply depressed and was again eager to leave France. He decided on Tahiti, in the Pacific, for his next expedition, and hoped some of his fellow artists would join him there. A farewell dinner was held at the Café Voltaire. Stéphane Mallarmé, the famed Symbolist writer, proposed the toast: "Gentlemen, let us drink to the return of Paul Gauguin ... seeking renewal in distant lands and deep in his soul."

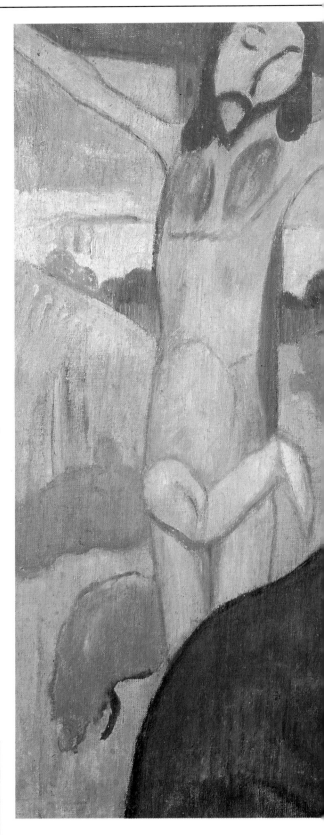

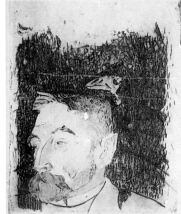

CHURCH CRUCIFIX
This 17th-century pale yellow carved Christ hangs in the little church of Trémalo near Pont-Aven. Gauguin typically used a ready-made religious artifact as the basis for his major Symbolist work, *The Yellow Christ*, 1889, which appears behind Gauguin in his canvas (right).

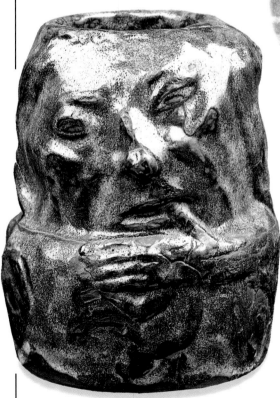

ANTHROPOMORPHIC POT, 1889
Also known as *Portrait of Gauguin as a Grotesque Head*, this is a stoneware tobacco jar with a dark brown glaze. Gauguin shows himself as the downtrodden artist and has deliberately chosen stoneware as the medium to create the effect he was looking for: "The character of stoneware is that of a very hot fire, and this figure, which has been scorched in the ovens of hell is, I think, a strong expression of that character."

ETCHING OF MALLARME, 1891
Stéphane Mallarmé was the leading Symbolist poet, and he and Gauguin held each other in high regard. It seems that in this etching Gauguin has given his subject something of his own aquiline profile. The raven may refer to their mutual admiration of Edgar Allen Poe (p. 56), and the faunlike sharpness of Mallarmé's ear may suggest one of the poet's own works, "*L'Après-midi d'un faune.*" This was Gauguin's only etching.

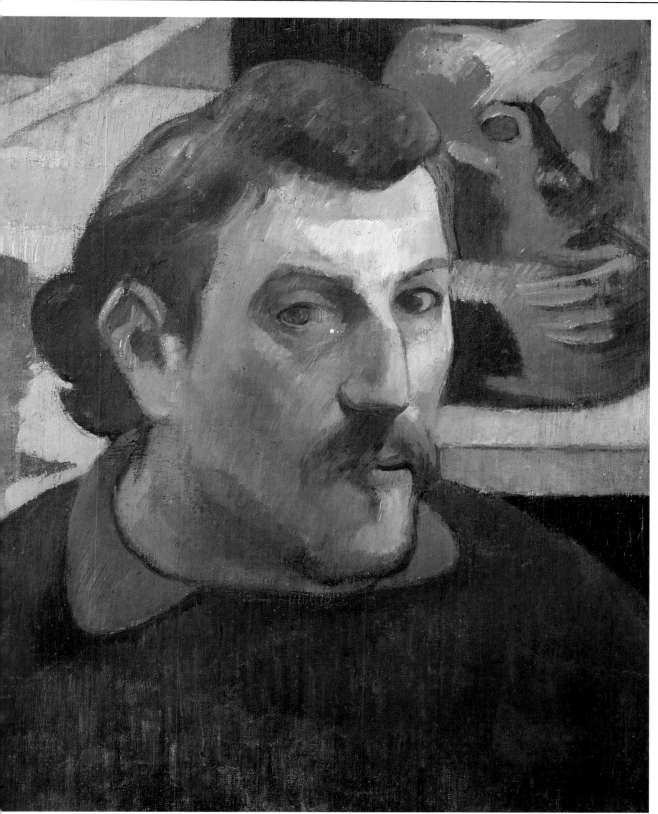

LEANING POT
The tobacco jar sits awkwardly on an imagined shelf. It was probably painted from a photograph, as Gauguin had given it away.

THREE FACES
A strange band of faces form a line across the painting, and the central face – that of the artist – is of a man trying to maintain control of his life. Gauguin painted himself in front of his work many times. However, the subjects here seem more loaded with meaning than in other paintings.

UNKNOWN HISTORY
The Yellow Christ, 1889, which forms the backdrop here, is a key painting about which very little is known. It was not exhibited during Gauguin's lifetime, and there is no mention of it in his writings.

A PUPIL
Maurice Denis, the *Nabis* painter and pupil of Gauguin, owned this work for many years, and wrote of it: "Like Cézanne, Gauguin seeks style ... Gauguin, who had so much disorder and incoherence in his life, would stand for neither of these in his painting. He loved clarity, which is a sign of intelligence."

Self-portrait with Yellow Christ

1889–90; 15 x 18 in (38 x 46 cm)

Painted during a period of intense depression and loneliness, this work shows a new maturity in Gauguin's art. He portrays himself in front of two recent works of art and uses them as symbols of his inner torment. The rationality and order visible in the composed figure of the artist are set against the sacrifice and despair suggested by the flanking images.

RELIGIOUS FIGURE
This drawing is an oddity in Gauguin's work, and the true interpretation is difficult to fathom. The word *Ictus* appears behind the figure – this is the Greek word for fish, and an early Christian symbol for Christ. The outstretched arm perhaps suggests resurrection.

The South Seas

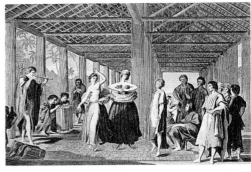

GAUGUIN ARRIVED IN TAHITI ON JUNE 9, 1891, after a ten-week voyage. He left behind a hard-won artistic position, and a large family – with whom his relationship had soured and who he would never see again. He hoped to find a country and a people where his art and personality could flourish. However beautiful the climate and landscape, it is easy to imagine his disappointment on arriving at the capital of Tahiti, Papeete, which was little more than a small shanty-town, dominated by a French bourgeois community. The Tahitian religion was no longer practiced, and artifacts were produced solely to feed the curio trade. Gauguin soon decided to leave Papeete for a remoter part of the island.

Tahitian pursuits, as recorded after Captain Cook's voyage there in 1769: notice the Westernized features of the dancers

MARQUESAS

TAHITI

NEW CALEDONIA

AUSTRALIA

Sydney
Melbourne

Auckland

NEW ZEALAND

The South Sea Islands and Australasia

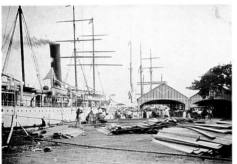

The port in Papeete in 1890; Gauguin arrived there a year later

VOYAGER ARRIVES
Gauguin had let his hair grow during his voyage to Tahiti, and on his arrival at the port in Papeete (left) the islanders nick-named him *taata-vahine* (man-woman). The ancient Tahitians believed the androgyne (a person of both sexes) to be a very charismatic figure.

CIVILIZED SOCIETY
This tinted photograph, from Charles Spitz's book of 1889, *Around the World*, clearly shows the impact of European life-styles on the island people. It also underlines how closely Gauguin, at least in his first works (right), showed the Western colonization of Tahitian life by painting native women in Western-style dress. Later he was to create a primitive, mythical image of the island and its people that was far from the reality, but would be readily believed by his European admirers.

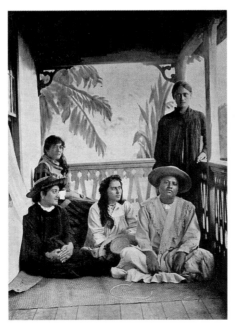

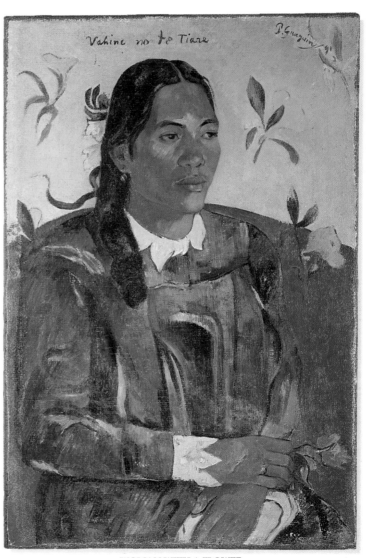

WOMAN WITH A FLOWER
1891; (27½ x 18 in)70 x 46 cm
Despite its apparent exoticism, this, one of Gauguin's first Tahitian paintings, reflects the Europeanization of Tahiti. The woman's dress is not native Tahitian, but a "modest" style of dress introduced by missionaries.

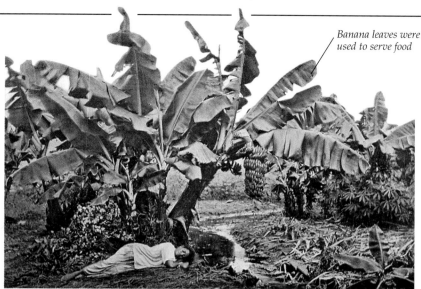
Banana leaves were
used to serve food

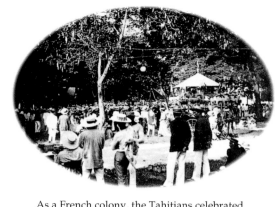
As a French colony, the Tahitians celebrated
the July 14, Bastille Day, in Papeete

WORK AND REST
A *bananier* (banana-picker) rests after a
hard day's work. The image of an easy
and abundant life was true in that food
and other essentials grew in profusion.
The main crops were bananas and bread-
fruit. However, the overriding influence on
life was the ocean, and the Tahitians
were traditionally skilled fishermen.

Smooth pua
wood, stained
and painted

The flowers are
gilded to add
color

HEAD OF A TAHITIAN WOMAN
1892; 9¾ x 7¾ in (25 x 20 cm)
Highly finished, this carving celebrates
the racial features of the Tahitians. The
model is probably Teha'amana (also
called Tehura), Gauguin's 13-year-old
vahine (mistress). A crude carving of a
nude female figure, probably Eve,
appears on the back.

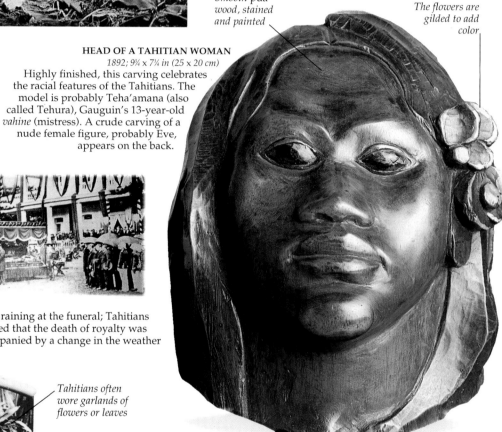

DEATH OF A KING
A few days after
Gauguin's arrival,
King Pomare V, the
last king of Tahiti, died,
marking the end of a
great Maori dynasty. It
was a personal blow to
Gauguin, who had
hoped the king would
become a patron.

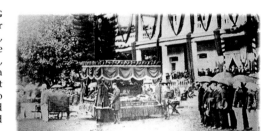
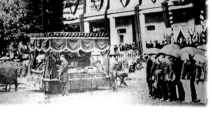

It was raining at the funeral; Tahitians
believed that the death of royalty was
accompanied by a change in the weather

Tahitians often
wore garlands of
flowers or leaves

The traditional
Tahitian pareu,
with plant motifs

NATIVE WORKERS
The realities of everyday
Tahitian life were not
depicted by Gauguin.
Women predominate in
his art, few people work,
and most adopt attitudes
of luxurious inactivity.
But in truth, the idyllic
life-style described by so
many writers had been
wiped out by 50 years of
white colonialist rule.

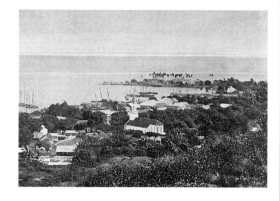

PANORAMA OF PAPEETE
A church at the center of this panoramic photograph
highlights the religious influence of the Europeans.
The islanders were rapidly converted to Christianity
after the arrival of missionaries in 1797.

Greeting a new world

GAUGUIN WAS AN ENTREPRENEUR, a true colonialist, forever on the lookout for markets to exploit. The "ecstasy, calm, and art" he desired from Tahiti took time to achieve, as he struggled to give form to his ideas. Reworking the Christian European tradition, and his knowledge of other religions, Gauguin chose as his subject matter the women and the landscape of the island. Gauguin's first trip to Tahiti resulted in 18 months of artistic activity, his works varying greatly in subject and style.

A gilded niche of tamanu wood

The lotus position emphasizes contemplation

IDOL WITH A PEARL
A female figure is seated in a Buddha-like position, while another, larger, figure emerges from behind. Gauguin was fascinated by the polytheism (belief in many gods) of some Tahitians, and this work incorporates several mysterious ideas within one small carving.

The gods Hina and Fatu, taken from a woodcut by the artist

Ia Orana Maria

1891; 45 x 34½ in (114 x 88 cm)
The Tahitian title translates as "I hail thee, Mary," the angel Gabriel's first words to the Virgin Mary. The Catholic subject of the Annunciation, set in a beautiful Tahitian landscape, produces a slight awkwardness in the composition.

MYTH AND RELIGION
A collage, pasted on page 57 of *Noa Noa*, shows how Gauguin combined the biblical imagery of the Garden of Eden with an imaginative reworking of a Tahitian creation myth, involving Hina, the goddess of air, and her son Fatu, the animator of the earth.

A photograph of a native woman wearing a Christian cross

The garden may illustrate the legend of Hero, the god of thieves, which Gauguin recorded

SOURCE MATERIALS
Gauguin used motifs from his store of images in a fantastical landscape. The source for the two figures in the center is a relief carving in the Javanese temple of Borobudur. Mary's calm expression may have been borrowed from Botticelli.

KEEPING RECORDS
Gauguin pasted a woodcut of *Ia Orana Maria* into his Tahitian notebook, *Noa Noa*, completed on his return to Paris in 1893.

MYSTERY AND MEANING
Symbolically, the painting is both obvious and mysterious. The heads of Mary and the Christ child are encircled by haloes, but the figure of the angel is far more obscure in meaning, especially since it is partially hidden by a tree.

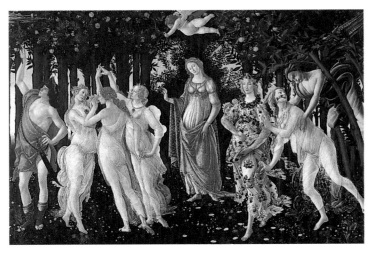

PRIMAVERA
Sandro Botticelli; 1478; 80 x 123¾ in (203 x 314 cm)
When he traveled to Tahiti, Gauguin took reproductions of paintings by Botticelli (including this one), Holbein, Delacroix, and others, as well as photographs of the Borobudur Temple in Java (p. 43). They were a constant source of inspiration.

SETTING THE SCENE
Gauguin celebrates the vibrant colors of the Tahitian landscape: a still life of red and yellow bananas fills the foreground; the women are wrapped in bright native cloth; and a dramatic lilac landscape forms the backdrop.

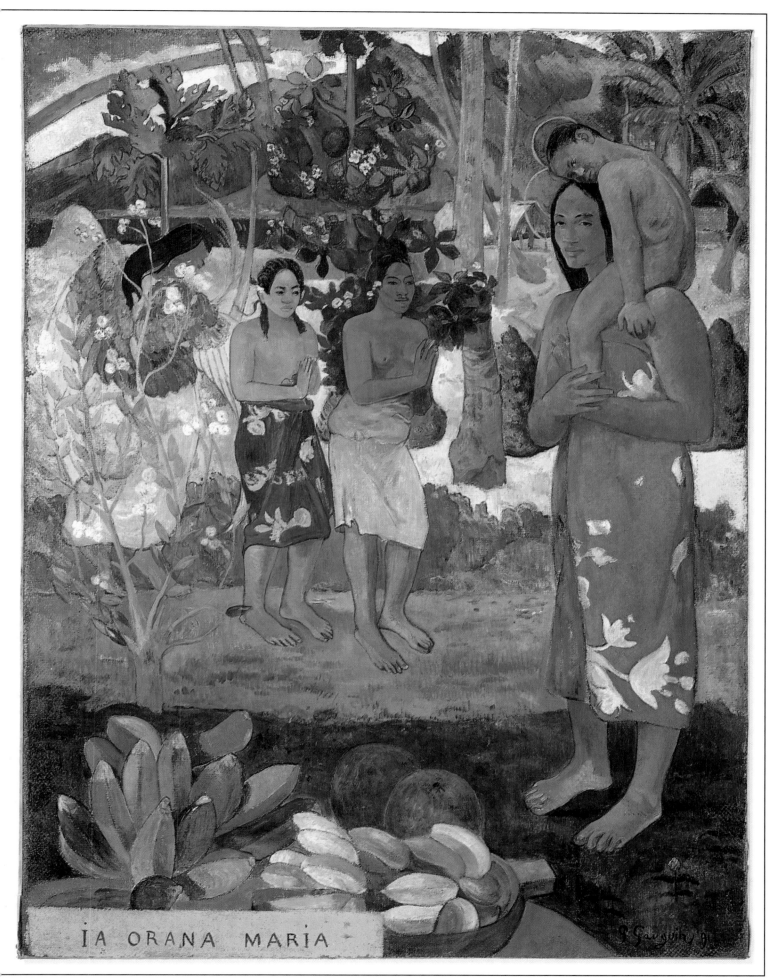

IA ORANA MARIA

In search of lost gods

YEARS OF COLONIAL RULE had destroyed the indigenous religious practices of Tahiti and eroded local customs. Gauguin grasped every opportunity to discover the "primitive splendor" of a now vanished way of life, which he could resurrect in his art. He talked to anyone interested in Tahitian culture and in maintaining the ancient traditions. The artist also studied J. A. Moerenhout's *Voyage aux Iles du Grand Océan*, published in 1837, a popular book that recounted the long-forgotten legends of the Maori people.

Mother-of-pearl shell

Inlaid bone teeth suggest the violence of ancient beliefs

Carved from local iron wood (toa)

A Buddha-like pose contrasts with the ferocity of the idol's face

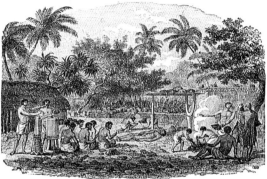

BLOOD RITES
Human sacrifices and cannibal rites were common in Tahiti. Offenses against the chiefs and superiors, and violations of social rituals, such as meeting mourners at a funeral, demanded sacrifice, as did the worship of gods.

FEATHER GORGET
This gorget, or chest ornament, would have been worn by a Tahitian king as part of his ceremonial dress. Tahitian artifacts were usually of a simpler design than those of neighboring islands.

Gorgets were collected as trophies by early explorers

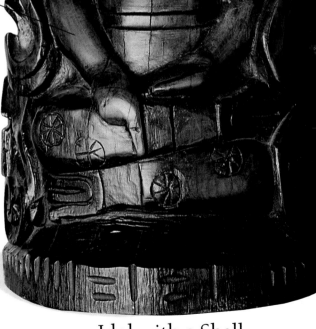

Idol with a Shell

1892; 10½ x 5½ in (27 x 14 cm)
An accomplished sculptor, Gauguin's deliberately "primitive" style was quite complex. His technical ability enabled him to create a powerful evocation of dark mysterious forces in this relatively small carving.

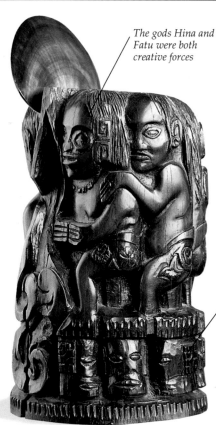

The gods Hina and Fatu were both creative forces

Severed heads encircle the base

SIDE VIEW OF IDOL
Gauguin incorporated various legends and motifs within one sculpture to express the polytheistic (many-spirited) nature of the ancient Tahitian religion.

NATURAL TEMPLE
Very little remained of traditional religious beliefs; the native people had never built permanent shrines or erected large statues. This early photograph shows the remains of a temple to be little more than a clearing in the forest.

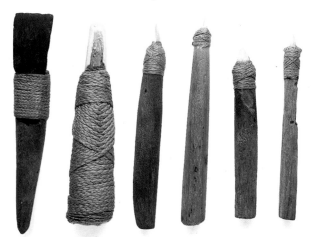

The fetal appearance of this sculpture symbolizes fertility

The Tahitians worked mainly in wood, adding stone, shell, and bone

MONUMENTAL GODS
The few *ti'ii* (sculptures in human form) that survive show a lack of individualization that did not appeal to Gauguin. He preferred to use other sources, such as the monumental stone sculptures of Easter Island and the Marquesas Islands and the photographs of Borobudur (left), for his own detailed depiction of "Tahitian" idols.

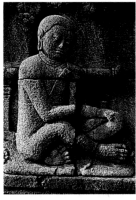

BUDDHA AT BOROBUDUR
Gauguin possessed images of the huge Buddhist temple of Borobudur, Java. His interest in it may have first been aroused by the Universal Exhibition (pp. 28–29). The graceful and stylized poses of its carvings appear frequently in his work.

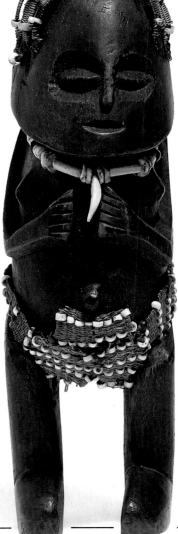

THE SORCERESS
This Tahitian female wooden figure is reputed to be an image of a sorceress. Many statuettes, believed to be invested with spiritual and magical qualities, were destroyed or buried by missionaries, and by the Tahitians themselves, fearful of their power.

CARVING TOOLS
Tools made from natural materials were used for all stages of the artistic process, from chopping down trees to carving tiny statuettes. Very tough volcanic rock was sharpened and shaped into adzes for cutting wood. Bones, shells, and teeth, varying in size from rats' to sharks', were used for more intricate work.

Spirits of the dead

"THE POLYNESIANS BELIEVE that the phosphorescences of the night are the spirits of the dead. They believe in them and dread them," wrote Gauguin. He related how he returned home late one night to find his young companion, Teha'amana, lying on her bed, frozen with fear. She believed that being without a light made her prey to the *tupapaus* (the spirits of the dead) that walked by night. One of the few remaining primitive beliefs, the fear of the dead occupied a very real place in the life of the Tahitians. Gauguin was proud of his successful expression of their "primitivism" in this painting.

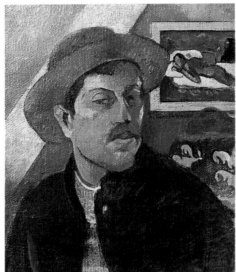

SELF-PORTRAIT
1893–94; 18 x 15 in (46 x 38 cm)
Painted on his return to Paris, Gauguin has shown himself in front of the painting (right), a macabre "spirit of Tahiti" watching over him.

The "phosphorescences" were Tahitian flowers that shone at night

RECURRING IMAGES
This woodcut, on the same theme as *Spirit of the Dead Watching*, was cut by Gauguin in the summer of 1894. He has intensified its power by replacing the sexually explicit pose of his companion, Teha'amana, with one which is much more suggestive of her terror of the night.

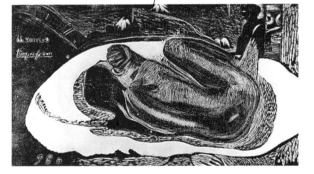

WATERCOLOR SKETCH
This sketch is taken from *Noa Noa*. It appears alongside the story of Gauguin's return to his terrified companion, described above. Gauguin compiled *Noa Noa* as an illustrated journal of his time in Tahiti (p. 48).

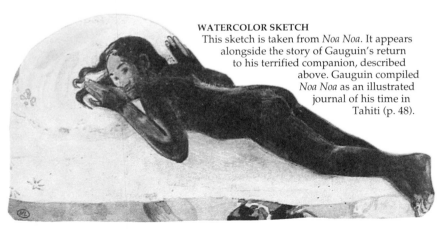

The Spirit of the Dead Watching

1892; 28½ x 36 in (73 x 92 cm)
Gauguin wrote to Mette and others explaining the significance of this painting, and its basis in reality. Some saw it as a reworking of Manet's notorious painting of a nude, *Olympia*.

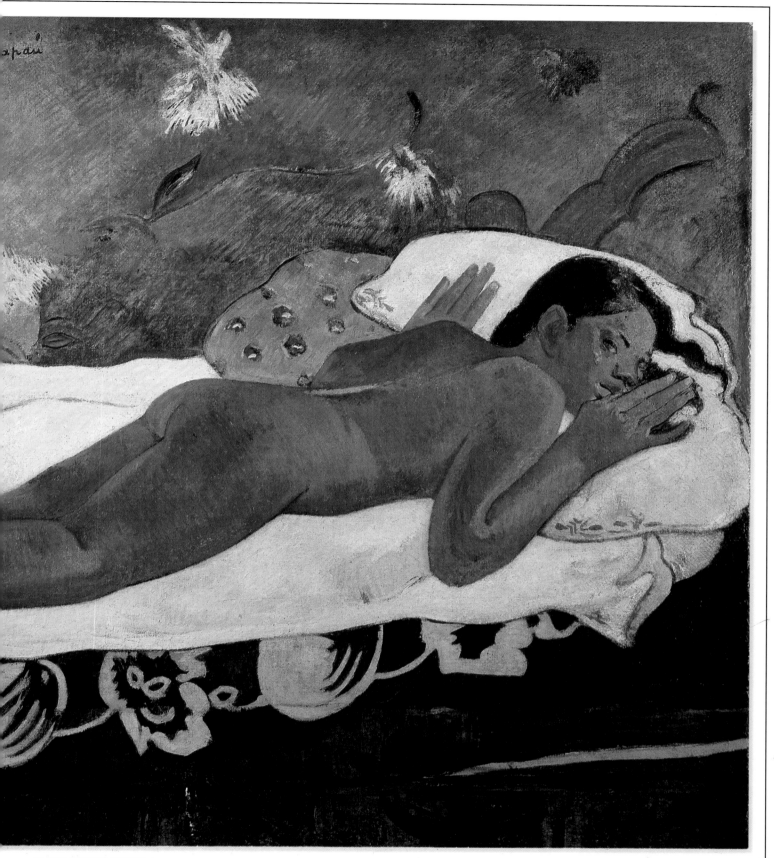

🖌 **THE SUPERNATURAL**
By likening the specter to a little, harmless old woman, Gauguin tries to express the Tahitian belief in the supernatural as part of the natural order: "The girl can only see the spirit of the dead linked with the dead person, that is, a human being like herself."

🖌 **HUMAN NATURE**
"I painted a nude of a young girl. In that position, a trifle can make it indecent. ... A European girl would be embarrassed to be found in that position; the women here not at all...." So Gauguin wrote of the non-mythical, and more obviously sexually suggestive, aspect of the painting.

🖌 **DEATHLY HUES**
Gauguin wished to achieve a somber, frightening effect, reminiscent of a "death knell," using hues of violet, orange, and blue. The ghostly yellow tones suggest not only the artificial light, necessary at night, but the color of the linen the Tahitians used, made from beaten bark.

Pastoral scenes

PIGMENTS
Gauguin was aware that by mixing pure pigments, as shown above, he was creating the decorative effect similar to that found in an old tapestry.

"I OBTAIN SYMPHONIES, harmonies that represent nothing real in the absolute sense of the word...." Gauguin's ambition was to create a decorative art that would work on the imagination of the viewer like music. He did not wish to produce a simple representation of the real world by colors or lines, but by "the mysterious affinities between our brains and such arrangements of colors and lines." It is probably a nocturnal scene – the idol in the top left-hand corner is Hina, goddess of the moon. The Tahitian flute, which the figure on the left is playing, was particularly associated with the night in Gauguin's mind.

 Cobalt blue

 Viridian

Yellow ochre

 Chrome yellow

Cadmium orange

 Crimson lake

ARTIST'S PALETTE
This is a possible breakdown of the paints used in *Arearea*.

Arearea

1892; 29½ x 37 in (75 x 94 cm)

Arearea (meaning amusement) was one of a series of three canvases which Gauguin felt to be his best Tahitian work. By incorporating Tahitian myth, he extended the European tradition of romantic pastoral painting, developed by artists such as Giorgione and Titian, and practiced still.

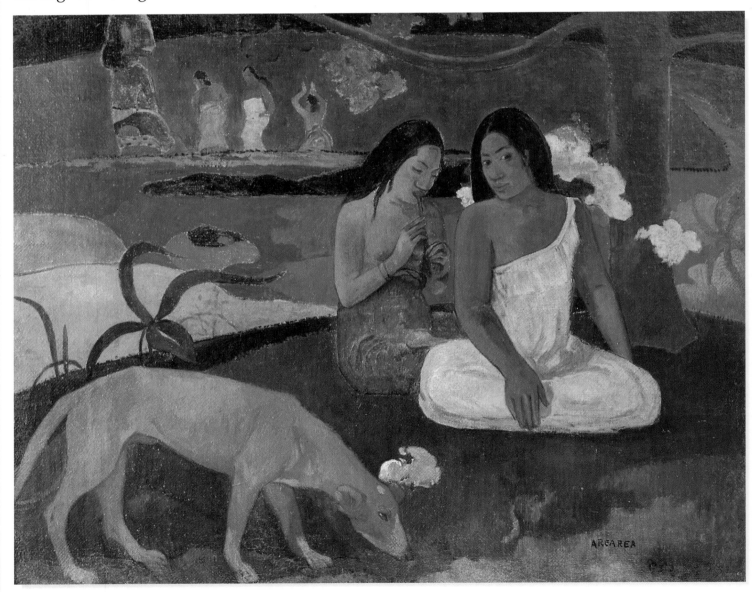

TAHITIAN GODDESS

The idol is reminiscent of a *ti'ii* (pp. 42–43), but the typical solid stone facade is represented by surprisingly thin layers of pale colors. The delicate lilac hues set the idol apart from the richer more defined colors of the rest of the canvas. The idol Gauguin depicts here is Hina, the Tahitian goddess of the moon.

STITCHING EFFECT

The painting seems to have the texture of a tapestry; this is created by a relatively thin and unmodulated layer of paint, applied over the rough weave of the canvas. The textile analogy is carried throughout the painting by the curious stitchlike effect, which Gauguin uses to join the color areas of the painting.

Dark dots create a stitching effect

Blue-black outlines bound the muted colors

The idol, unlike the main figures, is not outlined with color, but with bare canvas

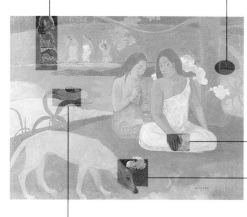

Solid blocks of color suppress a sense of perspective

SCULPTING WITH SHADOWS

The blue outline is overpainted to soften the overall effect and unify the painting. The pose of the main figure is Buddha-like, and the white robes suggest she is a priestess.

Darker tones create the effect of folds of fabric

A rare example of impasto

GOLDEN DOG

The gingery orange of the dog is deliberately artificial; it is the color of a Buddhist monk's robe. The same dog appears in a number of paintings. Its significance is unclear, but Gauguin seemed to like one critic's interpretation of it as an evil genie. The dog in particular horrified many of the people who saw the painting at Durand-Ruel's gallery in 1893. Behind the dog's head a rare touch of impasto may be seen, projecting above the canvas texture, in the fallen white blossom.

DECORATIVE LANDSCAPE

The middle ground of the painting is entirely imagined – neither color nor shapes are real. The flat decorative areas of warm color create lyrical shapes. These can only be deciphered by reference to other parts of the composition – they seem to represent a lagoon with rocks and exotic plants.

Return to Paris

IN TAHITI GAUGUIN HAD LONGED FOR PARIS. He had been desperately ill, and concerned over his reputation and the handling of his business affairs. Shortly after his return to Paris in September 1893, he received a legacy of 13,000 francs, which he did not share with Mette. In the spring he took a nostalgic trip to Brittany, where a fracas with some sailors at the port of Concarneau resulted in a broken ankle, an injury that never properly healed. Gauguin organized two sales of his work in Paris. Receipts from both were disappointing, although several purchases were made by Degas.

NOA NOA
To both explain and popularize his Tahiti experiences, Gauguin produced a book entitled *Noa Noa*, which translates as "richly fragrant." The book was illustrated and presented an idyllic and primitive society. Many of the legends recounted in the book derive not from conversations with his Tahitian *vahine* (mistress), as Gauguin states, but from Moerenhout's book on the subject (p. 42).

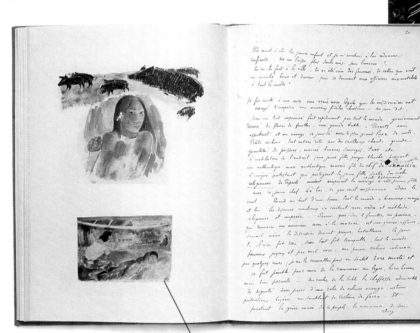

The interior of a traditional Tahitian communal long-hut

Gauguin's handwritten text showing additions and corrections

NOA NOA WOODCUT
This woodcut is one of ten intended for *Noa Noa*. The Tahiti evoked in these images is dark and mysterious, almost impenetrable. Some of the proofs were painted with watercolor, and each one was different.

TAHITIAN FIGURES
These quickly drawn Tahitian watercolor sketches appear in *Noa Noa*. They capture the color and apparent ease of life in Tahiti.

The style of the painting seems to suggest the influence of Camille Pissarro

Fans were a popular shape for decorative works

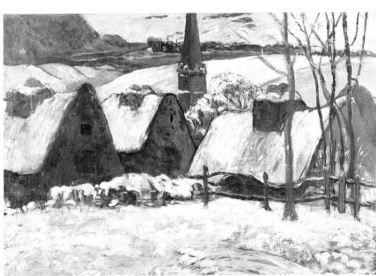

BRETON VILLAGE IN THE SNOW
1894; 24½ x 34¼ in (62 x 87 cm)
A nostalgic image of snow-covered buildings huddled around a village church suggests the attachment Gauguin felt toward Brittany. There was no snow in the winter of 1894–5, and so this painting could be an imaginary depiction.

ANNAH THE JAVANESE
1893–4; 45¼ x 31½ in (116 x 81 cm)
The full title for this painting is very curious: *Aita tamari vahine Judith te parari* (The child woman Judith is not yet breached). This half-legible inscription is visible in the top right-hand corner and refers not to the model, Annah, but to a European girl of the same age. A coloristic masterpiece, the vibrant harmonies and the dramatic composition create an unforgettable image. Annah's monkey, Taoa, adds a quixotic note to the exotic splendor of this study.

THE DELIGHTFUL LAND
Another of the ten woodcuts for *Noa Noa*, produced in Paris, the lettering PGO placed within the decorative border refers to the artist himself. The image sets the Adam and Eve myth in the fabulous landscape of Tahiti. A dark Eve is tempted by a winged lizard, as she looks out conspiratorily at the viewer.

ENTERTAINING IN THE STUDIO
This photograph taken in Gauguin's studio shows something of the Bohemian life-style Gauguin followed. He loved music and played the mandolin and harmonium. The picture does not feature Gauguin, but Annah the Javanese, his 13-year-old mistress from Ceylon (now Sri Lanka), is in the center.

CHATEAU AT MEDAN
Paul Cézanne; 1880;
23¼ x 28½ in (59 x 72 cm)
This painting of Emile Zola's house was bought by Gauguin; on his return to Paris he discovered that Mette had sold it to pay the family expenses. He tried unsuccessfully to retrieve it; Gauguin worshiped Cézanne and bitterly resented the loss of this painting.

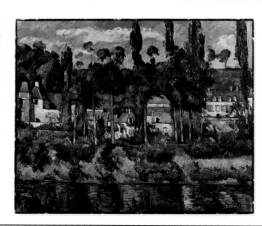

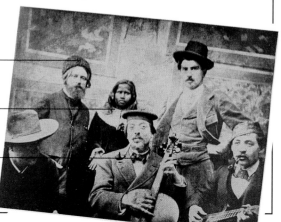

The painter Paul Serusiér (p. 21)

Annah the Javanese

The cellist Fritz Schneklud

Savage sculpture

Gauguin was again beset with financial and personal difficulties. He had lost his lawsuit against Marie Henry to recover the works of art he had left at her inn at Le Pouldu. An auction at the Drouot Hotel, Paris, had confirmed that he was unable to sell enough work to live according to his wishes. A return to Tahiti was almost inevitable. This time Gauguin hoped to go there accompanied by his friends, but one by one they dropped out. The artist reacted by creating the "ceramic sculpture" *Oviri* (Tahitian for "savage"), with whom he identified "in spite of himself." Gauguin felt that it was one of his best pieces, a view not shared by many of his contemporaries. Its rejection by the jury of the Societé Nationale of 1895 was only overturned by Ernest Chaplet's threat to withdraw all of his works in protest.

THE ARTIST AND HIS WORK
The determined pose reveals Gauguin's unshakable faith in his own genius. Behind him is the brooding presence of his painting *Te Faaturuma* (meaning "silence," or more aptly, "to be dejected.")

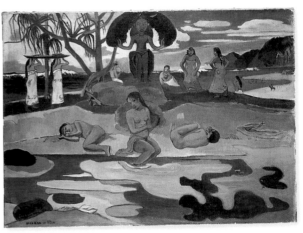

THE DAY OF THE GOD
1894; 26½ x 35½ in (68.3 x 91.5 cm)
Despite its extraordinary use of color, this painting is a transposition of standard academic French Salon painting into a Tahitian setting. The usual references to Greek culture have been exchanged for Gauguin's own rather hazy vision of Tahitian mythology. The figures and giant idol restate the artist's desire to celebrate what he considered to be the purity of a "primitive" culture. Tahitian life was still in touch with the natural cycles of life, and to Gauguin it seemed the antithesis of the decadent values of Europe.

GAUGUIN'S PALETTE
This portable folding palette, normally used for painting *en plein air* (outdoors), belonged to Gauguin. It was found in his last studio in the Marquesas, where the contents of his studio were auctioned off after his death. Unlike many artists who arranged their palettes following a set pattern of colors – in order to assist them with the mixing of paints – Gauguin does not appear to have set his colors in any order. It also seems he did not clean his palette after use, but that he mixed fresh colors on top of old, dried-up paint.

A thumbhole for holding the palette

Pegs prevent the paint on either side of the palette from mixing when the palette is closed

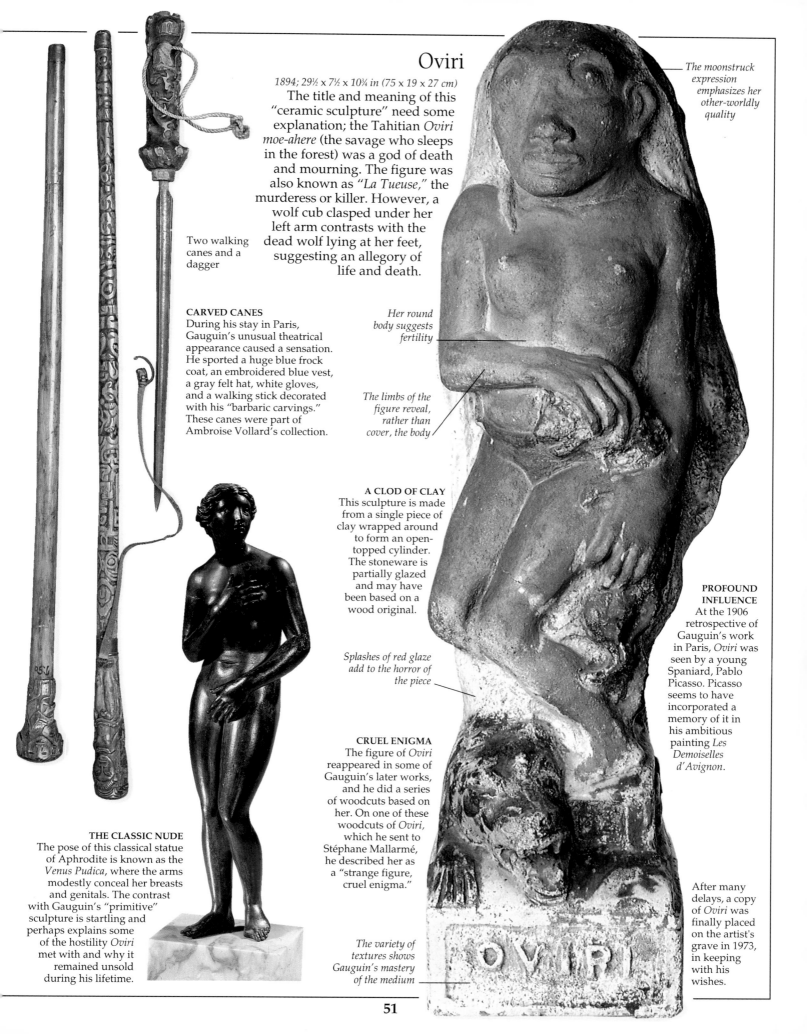

Oviri

1894; 29½ x 7½ x 10¾ in (75 x 19 x 27 cm)

The title and meaning of this "ceramic sculpture" need some explanation; the Tahitian *Oviri moe-ahere* (the savage who sleeps in the forest) was a god of death and mourning. The figure was also known as *"La Tueuse,"* the murderess or killer. However, a wolf cub clasped under her left arm contrasts with the dead wolf lying at her feet, suggesting an allegory of life and death.

The moonstruck expression emphasizes her other-worldly quality

Two walking canes and a dagger

CARVED CANES
During his stay in Paris, Gauguin's unusual theatrical appearance caused a sensation. He sported a huge blue frock coat, an embroidered blue vest, a gray felt hat, white gloves, and a walking stick decorated with his "barbaric carvings." These canes were part of Ambroise Vollard's collection.

Her round body suggests fertility

The limbs of the figure reveal, rather than cover, the body

A CLOD OF CLAY
This sculpture is made from a single piece of clay wrapped around to form an open-topped cylinder. The stoneware is partially glazed and may have been based on a wood original.

PROFOUND INFLUENCE
At the 1906 retrospective of Gauguin's work in Paris, *Oviri* was seen by a young Spaniard, Pablo Picasso. Picasso seems to have incorporated a memory of it in his ambitious painting *Les Demoiselles d'Avignon.*

Splashes of red glaze add to the horror of the piece

CRUEL ENIGMA
The figure of *Oviri* reappeared in some of Gauguin's later works, and he did a series of woodcuts based on her. On one of these woodcuts of *Oviri*, which he sent to Stéphane Mallarmé, he described her as a "strange figure, cruel enigma."

THE CLASSIC NUDE
The pose of this classical statue of Aphrodite is known as the *Venus Pudica*, where the arms modestly conceal her breasts and genitals. The contrast with Gauguin's "primitive" sculpture is startling and perhaps explains some of the hostility *Oviri* met with and why it remained unsold during his lifetime.

The variety of textures shows Gauguin's mastery of the medium

After many delays, a copy of *Oviri* was finally placed on the artist's grave in 1973, in keeping with his wishes.

Difficult times

ON HIS RETURN in September 1895, Gauguin found it difficult to sustain the idealized image of Tahiti he had cultivated in his previous work. He had a traditional hut built in Punaaiua, 3 miles (5 km) from Papeete, and looked around for a suitable *vahine* (mistress). Gauguin's final years were lonely ones; soon lack of funds forced him to leave his house and move to a suburb of Papeete. He took a position in the Office of Public Works and Surveys in the capital but on receipt of money from Paris he left and returned to his hut. It had been wrecked by rats and rain. He began to devote his energies to writing, and his artistic output suffered accordingly.

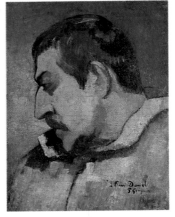

SELF-PORTRAIT
1896; 16 x 12½ in (40.5 x 32 cm)
Sent to Daniel de Montfried in Paris, the tired expression and somber tones reflect the difficulties Gauguin experienced on his return to Tahiti.

A tiny seated figure at the end of the spoon

The familiar carved initials, PGO

A favorite material, natural wood

CARVED SPOONS
An obsessive decorator, Gauguin enjoyed creating beautiful domestic objects, such as these spoons.

A WRITING CAREER
Gauguin's career as a political writer was fueled by the injustices of colonial life. Increasingly alienated from respectable society by illness and poverty, he fought his way into a new circle by founding the satirical journal *Le Sourire* ("The Smile"). Writing, illustrating, and editing the publication, from August 1899 to April 1900, Gauguin demonstrated his desire to involve himself with social and cultural matters.

FINANCING THE ARTIST
This letter from the dealer Vollard, dated October 26, 1901, informs Gauguin of how much money he had been sent. By 1900, Gauguin had an arrangement with Vollard: in return for sending him 20 to 24 paintings a year, the artist was to receive a monthly salary of 300 francs.

Vollard sends a check to Gauguin for 350 francs, more than the usual amount

The first four issues were printed using a press, but Gauguin soon started producing his own woodcuts by hand

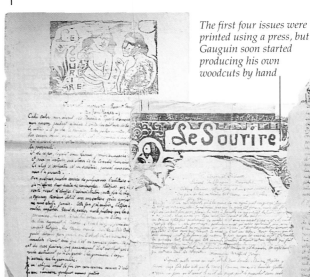

The "only illustrated journal in Tahiti" was handwritten

Mocking the greedy colonialists

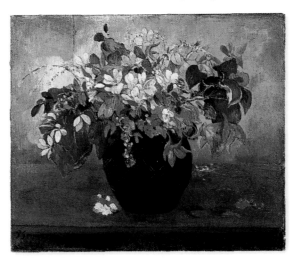

A VASE OF FLOWERS
1896; 25¼ x 29 in (64 x 74 cm)
Gauguin was probably not as impoverished as he made out in his letters, and he could have been wealthier if he had managed his affairs better. However, he was always aware of the need to satisfy the market and his dealer at home in Paris. To this end Gauguin produced some attractive still lifes such as this one, but he felt that they distracted him from his more imaginative compositions.

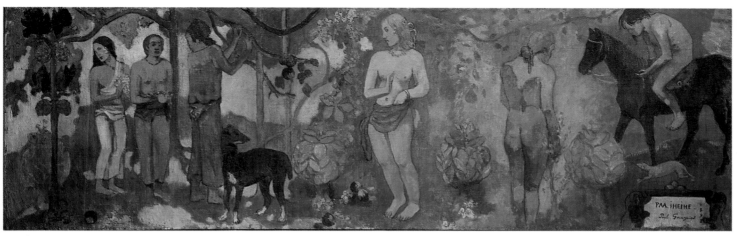

Tahitian pastoral

1898; 21¼ x 66½ in (54 x 169 cm)

A much smaller and more optimistic partner to *Where do we come from?* (pp. 54–55). Both works were shown at an exhibition of Gauguin's work at Vollard's gallery in the winter of 1898.

GILDED FRIEZE
The friezelike quality of the work reflects the influence of Botticelli's *Primavera* (p. 40), a photograph of which Gauguin pinned to the wall of his hut. The rich yellows recall the gilded backgrounds of early religious paintings.

GOLDEN PARADISE
The composition is decorative rather than symbolic, a calm evocation of figures, fruit, and flowers, people at ease in paradise. The central figure appears to be a goddess or priestess making some ritual gesture.

SUBTLE TITLE
The exact translation of the Tahitian title *Faa iheihe* is unclear: the Tahitian phrase is spelled wrong. The most likely meaning is "adorn" or "to beautify." To enhance the overall decorative effect, the title is set in an ornate panel.

For once, Gauguin paints a natural blue sky

ALINE GAUGUIN
Aline was Gauguin's favorite child: she had been named after his mother. Gauguin kept this photograph with him all his time in the South Seas. A short letter from Mette informed him that on January 19, 1897, she had died of pneumonia, aged 20. Gauguin never heard from his wife again. The depression that led to his suicide attempt may well have been sparked by his daughter's untimely death.

HOMES AND STUDIOS
Gauguin painted a watercolor of his home in *Noa Noa*. Natives built him a traditional hut (below), from palm leaves and bamboo cane. Gauguin enjoyed decorating his homes and studios – for his last home he sculpted elaborate panels, to frame the entrance to his bedroom and studio (pp. 58–59).

POLITICAL ACTIVITY
Gauguin became the editor of *Les Guêpes* ("The Wasps") in January 1900 and remained involved with the newspaper for just over a year. It was the mouthpiece of the Catholic party and was, in effect, a political organ used to attack the Protestant faction on the island.

NATIVE HUT
This photograph of Gauguin's house and studio in Punaauia suggests his relative affluence. The statue of the nude woman on the left was built to mock the classical statues adorning the garden of a wealthy lawyer, and previous employer, Auguste Goupil.

Fundamental questions

Toward the end of 1897, Gauguin's health and depression worsened to such an extent that he decided to end his life. Typically, he wrote to his friends informing them of his decision. On a 12½-foot (4-meter) length of coarse hemp sacking material, he began work on what he expected to be his final artistic statement. After finishing the painting, he claimed that he climbed to the top of a hill, took a massive dose of arsenic, and waited to die. However, the poison caused him to vomit, and slowly he returned to what he considered to be the living death of his existence.

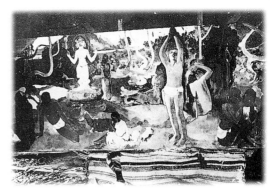

PHOTOGRAPH TO A FRIEND
The huge canvas was photographed in Gauguin's studio on June 2, 1898. The photograph was sent to Daniel de Monfried, who had provided the paints for the canvas.

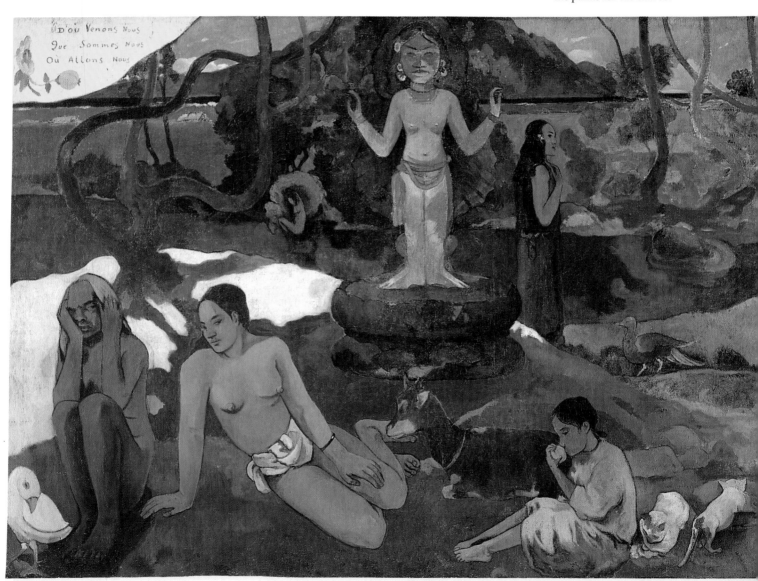

Where do we come from? What are we? Where are we going?

1897; 54¾ x 147½ in (139 x 375 cm)
This painting is deliberately symbolic, and far removed from reality. Gauguin's explanation is couched in mysterious language: "Where are we going? Near the death of an old woman. A strange simple bird concludes. What are we? Mundane existence. The man of instinct wonders what all this means.... Known symbols would congeal the canvas into a melancholy reality, and the problem indicated would no longer be a poem."

SQUARED-UP SKETCH

Gauguin claimed he made no preparations for his philosophical masterpiece, that he painted it intensely and instinctively. However, this squared-up drawing on tracing paper seems to suggest otherwise. It might well have been a preparatory sketch that was later presented as a memento to a friend, as the inscription suggests.

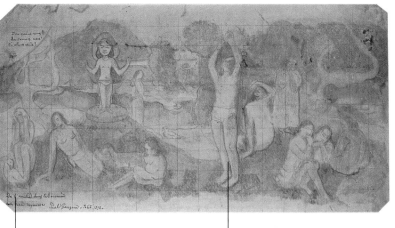

The inscription reads: "This pale sketch to... in remembrance of friendship"

Gauguin has used brown pencil and blue watercolor

THE POOR FISHERMAN

Pierre Puvis de Chavannes; 1881;
61 x 75½ in (155 x 192 cm)
Gauguin admired the allegorical and decorative paintings of this artist. He had a copy of this painting with him in Tahiti, and there is some resemblance between the babies in the two canvases.

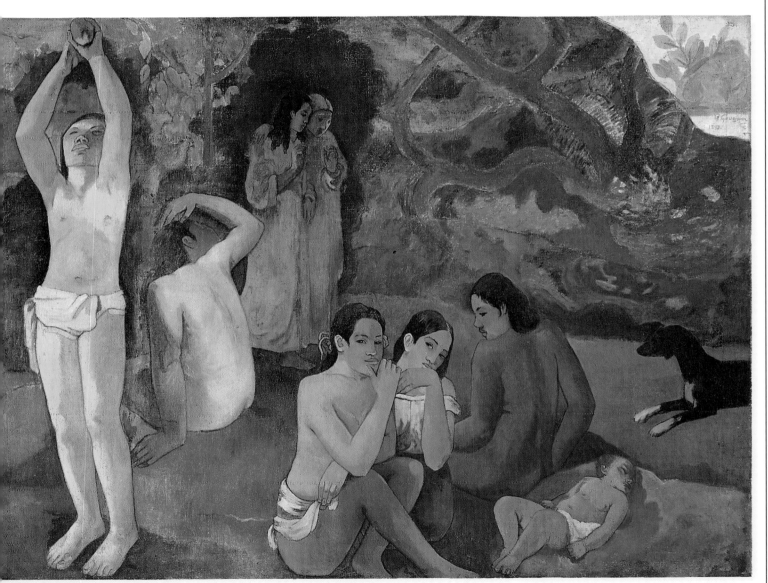

SYMBOLIC FIGURES
The painting reads from right to left, following Eastern ways of reading. A baby represents the beginning of life, an old woman awaiting inevitable death, the end. According to Gauguin, the idol (top left) does not represent a Tahitian goddess, but a woman becoming an idol, pointing to heaven.

MYTH AND MYSTERY
The work is deliberately mysterious, yet several of Gauguin's preoccupations are clearly suggested, particularly his fascination with religious belief. The landscape represents a Garden of Eden; the tree, the tree of knowledge. The somber, robed figures deep in conversation symbolize rationality.

QUESTIONS AND ANSWERS
Through his use of somber ochres, deep, harmonious blues, and ambiguous imagery, Gauguin hoped to create a powerful "musical" effect. Viewers are left to use their own imaginations to construct personal answers to the fundamental questions posed by the title. For Gauguin, it is the depiction of a vision.

A barbaric nude

THE OPENNESS AND CANDOR of Gauguin's nudes were made more acceptable to the public because of the South Sea Islanders' reputed sexual promiscuity and because the artist provided an eyewitness account. The curves of the headboard and the suggestive decorative motifs of the interior reinforce the heady atmosphere of the painting. Gauguin wrote in a letter to Daniel de Montfried, "By the means of a simple nude I wanted to suggest a certain barbaric luxury of ancient times. The whole is suffused in colors which are deliberately subdued and sad. It is neither silk nor velvet, nor muslin, nor gold that makes this luxury, but simply the material made rich by the hand of the artist."

Mars black

Cobalt violet

Emerald green

Red ochre

Cadmium yellow

Zinc white

ARTIST'S PALETTE
The bright flat colors of Gauguin's earlier Tahiti paintings have given way to rich somber tones.

THE HIDDEN LANDSCAPE
An x-ray film of *Nevermore* has revealed the existence of an earlier horizontal landscape with figures. Gauguin covered it with a coat of thick white paint, which explains the absence of the canvas texture usual in Gauguin's oil paintings.

Nevermore

1897; 23¾ x 46¾ in (59.5 x 117 cm)

This painting takes its title, written in English in the top left-hand corner, from "The Raven," a poem by Edgar Allen Poe, a favorite author among the Symbolist writers. It echoes with the haunting refrain "Quoth the raven 'Nevermore.' " The bird in this painting, however, is a bird of death, sightless and predatory.

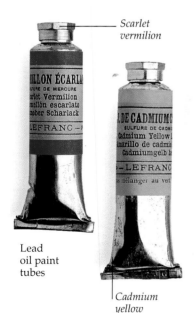

Scarlet vermilion

Lead oil paint tubes

Cadmium yellow

TUBES OF PAINT
Gauguin's correspondence is full of the problems he had in obtaining regular supplies of oil paint. Paint dried quickly in the tropics, and so Gauguin had to work quickly. In a letter to Vollard, the dealer who supplied him with paints, Gauguin wrote, "Now that I am in the mood for work I shall simply devour paints. So buy Lefranc's decorators' colors, they cost a third as much and are much better."

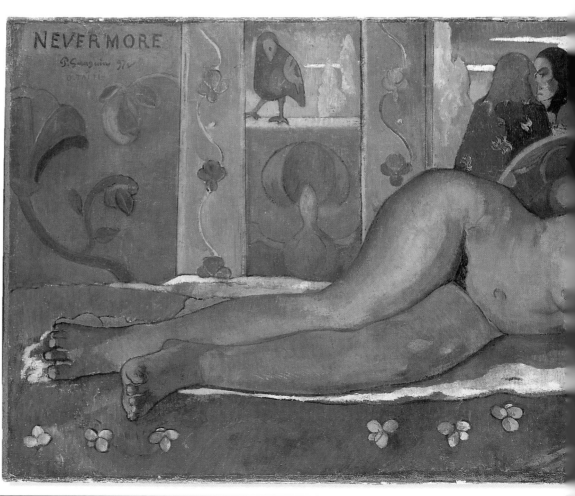

FOOT HIGHLIGHT

The firm shaping of the feet is set against a loosely worked white sheet, brilliantly offset by the enclosed patches of pure vermilion. By extending the sheet beyond the toes, Gauguin has created a sculpted detail. The strong sculptural modeling of the entire body gives the figure a sense of reality in a flat, two-dimensional picture plane, despite its strong, dark outlines.

SIGHTLESS BIRD

The bird, painted in blue, green, and purple, is a decorative detail. However, Gauguin saw this sightless bird as the "bird of death," and so its presence is unsettling.

The treatment of light and shadow recalls Gauguin's Brittany paintings

Gauguin mixed wax with his paints to achieve a smooth surface

Painted wet-on-wet, allowing close tones to be worked together

WAITING FIGURES

Firmly drawn contour lines lock the two sinister figures together in their enigmatic conspiracy. They may suggest spirits of the dead (pp. 44–45) or simply two passersby. A tense atmosphere is heightened by the conjunction of the real world with that of the imagination. The sinister figures confer in what looks like full daylight, contradicting the nocturnal mood of the interior.

The eyes are turned away from the spectator

A ghostly luminous lemon yellow

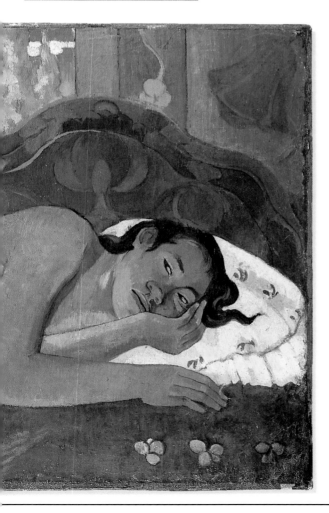

A touch of red enlivens the dull greenish yellow tones of the finger

AVERTED EYES

The contours and features of the figure are strongly drawn in Prussian blue, emphasizing the flatness of color in the rest of the painting. Gauguin wrote: "It is painted badly (I am so nervous and I work only in bouts) but no matter; I think it is a good canvas."

The final years

In September 1901, Gauguin arrived at Hiva-oa in the Marquesas, the most isolated islands on earth, never to return to his homeland. Although dogged by vision problems and continual bad health, this final move seems to have reactivated his creative energies. Playing the role of a good Catholic, he bought a piece of land; neighbors helped him build his "House of Pleasure." Popular with the natives, he fought for justice for the local population against the colonials. Still striving for ideals in life and art, he wrote to Charles Morice in Paris, "If we win ... I shall have done a great thing in the Marquesas. Many iniquities will have been done away with and that will have made all of the suffering worthwhile."

Men's entire bodies could be tattooed; on women, only the buttocks and hands

TATTOOING TOOLS
Tattooing was a traditional custom in the Marquesas. Combs were dipped into a blue dye, obtained from burning candlenut. The teeth of the comb penetrated the skin, creating patterns.

THE TATTOOED CHIEF
Gauguin wrote of his fascination with the tattooed men of the Marquesas. This photograph shows a Marquesan chief, resplendent in his tattooed body. The islands were among the last to be colonialized, and the islanders had a sinister reputation for cannibalism.

Door panels

Gauguin's "House of Pleasure," 1902, was his last great decorative work. The public space of the house was at ground level; above were Gauguin's private quarters and studio. Access to his working space was only possible through the bedroom, which was liberally decorated with pornography. The panels framed the entrance to his bedroom and studio, declaring the "House of Pleasure" within.

BISHOP MARTIN
Gauguin's activities, artistic and otherwise, greatly upset the colonial community. Bishop Martin, who had sold Gauguin the land for his house, was incensed by the artist, who flaunted his Bohemian life-style.

The panels were carved from redwood and painted

Gauguin copied these heads from paintings of this period

A favorite phrase instructs, "Be Mysterious"

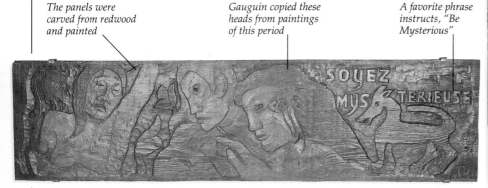

MODELS AND MISTRESSES

This photograph, c. 1901, is of the redhead Tohotua, who modeled for Gauguin in his final years (p. 61). On the wall are some of the reproductions Gauguin brought from Paris, including Holbein's *Woman and Child*. Gauguin was suffering acutely from syphilis, making it difficult to find young girls to share his bed. In his sexual affairs he behaved in the worst kind of colonial fashion.

The lintel is almost 98 in (2.5 m) long

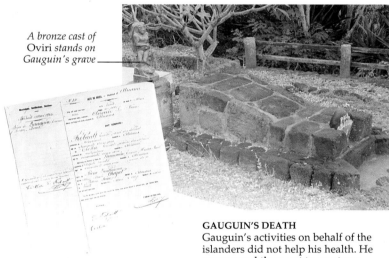

STILL LIFE
1897; 29 x 36½ in (73 x 93 cm)

This stunning still life is painted on a relatively large scale, on very rough canvas. The texture of the canvas enhances the overall richness of the painting. The fruit at the left of the painting shows the influence of Cézanne; Gauguin once owned his painting *Fruit Bowl, Glass and Apples*. The exotic blooms are arranged in a carved wooden bowl.

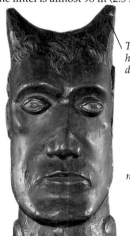

The "bishop" has carved devilish horns

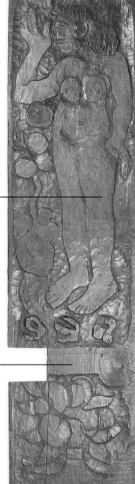

Two female nudes decorate the vertical panels

A bronze cast of Oviri stands on Gauguin's grave

A gap was left in the carving to fit the stair rail

Gauguin's death certificate

GAUGUIN'S DEATH

Gauguin's activities on behalf of the islanders did not help his health. He encouraged them not to pay taxes, and not to send their children to the Catholic school. Eventually sentenced to imprisonment for slandering the governor and others, he wrote to Montfried, "All of these worries are killing me." Gauguin finally died, probably from heart disease, on May 8, 1903, and was given a Christian burial in the Catholic cemetery of Hueakihi.

The images and motifs chosen are not overtly symbolic

Again, a favorite maxim instructs, "Be in love and you will be happy"

FATHER LECHERY

This satirical carving of Bishop Martin stood in Gauguin's garden. Gauguin wished to humiliate the bishop, who had censured his licentious ways although he was apparently guilty of similar misdeeds.

Gauguin's legacy

"YOU HAVE KNOWN for a long time what I have tried to achieve: the right to dare all." Gauguin died at the comparatively early age of 54, having lived and worked with an amazing energy. Ambroise Vollard, his dealer, held an exhibition of his work in 1903, just five months after the artist's death. A large retrospective was organized in 1906 which laid the basis for his future reputation. The influence of his "primitive" art, cutting across the realism and science of his contemporaries, the Impressionists and Neo-Impressionists, was felt almost immediately. Together with Cézanne and van Gogh, he set the standard for the self-conscious avant-garde artists of the early 20th century. Gauguin, the suffering artist, the victim of a "civilized society," has become one of the cultural myths of our time, the quintessential "romantic artist." The raw color, mystery, exoticism, and profoundness of his work have been a source of inspiration for countless artists.

LA VIE
Pablo Picasso; 1903; 77½ x 51 in (197 x 129.5 cm)
This enigmatic painting from Picasso's "Blue Period" (1901–4) is reminiscent of Gauguin's symbolic work. Here, archetypal figures – despairing couples, a lone woman, a mother and child – present a vision of life that must be deciphered by the viewer. Picasso was interested in allegory and the ability of art to deal with the wider issues of life and death. In Gauguin, he saw an artist of similar philosophical ambitions.

INTIMATE JOURNALS *below*
Gauguin's writings confirm his place in the romantic myth of the artist as an outcast. In *Avant et Après* ("Before and After"), begun in 1902, he attempted to clarify his artistic beliefs and to give a satisfactory account of his life.

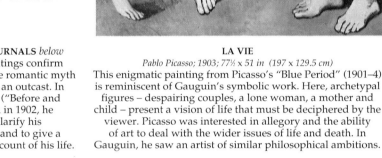

Gauguin's final statement is on the importance of the question, "What is art?"

Dated February 1903, Marquesas, Atuana, this is Gauguin's last piece of writing

A facsimile edition of Avant et Après

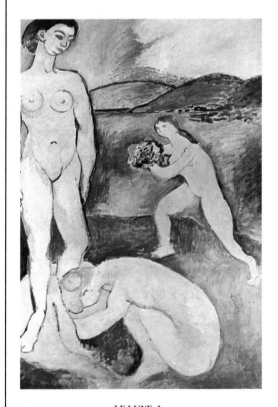

LE LUXE, I
Henri Matisse; 1907; 82¾ x 54½ in (210 x 138 cm)
Matisse's use of the curving line, embracing flat areas of color, derives from a close study of Gauguin's decorative work. This idyllic view of untroubled female activity lacks the darker connotations apparent in much of Gauguin's later work. Like Gauguin, Matisse worked in many media and borrowed from many sources.

Primitive Tales

1902; 51¾ x 35½ in (131.5 x 90.5 cm)
This late painting resounds with Gauguin's belief: "Primitive art comes from the spirit and makes use of nature." The figures may represent the East, West, and Polynesia, the opposition between civilization and a life of nature. The emotional power of the painting is clear but, like the artists who followed him, Gauguin leaves the viewer to interpret the symbols.

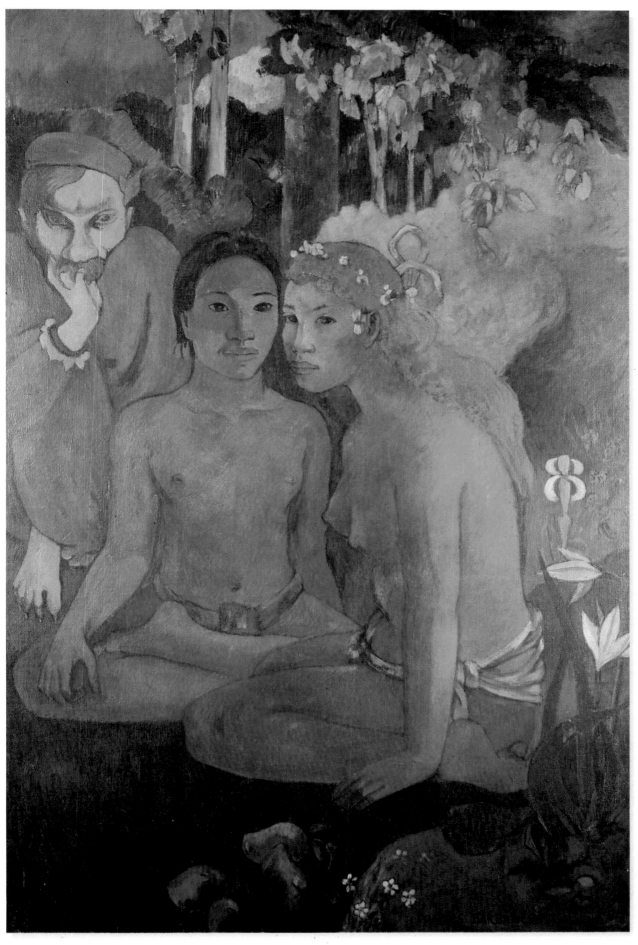

DEVIL-MAN
Meyer de Haan, Gauguin's friend from Le Pouldu, appears as an ominous devil-like presence with clawed feet to prey on the two Tahitian beauties. The foxy features are only part of the general strangeness of this European intruder, who seems to be wearing a missionary dress.

STYLIZED FACES
The simple and stylized expressions of the women contrast with the cynical brooding of the man. A staring, mesmerized de Haan dominates the left of the canvas; the vacant eyes of the central figure and the reverie of Tohotua (the red-haired figure) suggest a certain stillness.

PERFUMED NIGHTS
The unusual coloration of Tohotua picks up the red so evident in the male figure and the earring of the girl in the Buddhist lotus position. The blue and purple tones that dominate evoke the beauty of a Tahitian night. The flowers around the figures conjure the heady perfume of such nights.

FOLKTALES
The French title, *Contes Barbares*, which is written in the bottom right-hand corner, is hard to interpret – *Contes* translates as "tale," specifically a popular folktale. Some have seen the women as story-tellers, weaving tales of mythical truth. However, there is no real evidence to support this in the painting.

Key biographical dates

1848 Eugène-Henri Paul Gauguin born in Paris, June 7, to Clovis Gauguin, a journalist from Orléans, and Aline, his Peruvian wife.

1849 The family leaves for Peru; father dies during the journey.

1854–1855 Return to France. Education in Orléans.

1862 Attends pre-naval college in Paris.

1865–7 Joins the merchant marines; journeys around the world on the *Luzitano* and the *Chili*.

1867 Learns of mother's death.

1868 Enlists in the military; registered as a third-class sailor, on the *Jérôme-Napoléon*.

1870 Franco-Prussian War declared; his ship, the *Jérôme-Napoleon*, sees action.

1871 Through his guardian Arosa, finds job as a stockbroker at Banque Bertin. Meets Emile Schuffenecker.

1873 Marries Mette Gad; they have five children over the next ten years.

1874 Meets Camille Pissarro. Is a weekend painter and sculptor. Collects Impressionist paintings. First Impressionist exhibition.

1880 Exhibits at the fifth Impressionist exhibition; exhibits in the remaining three.

1882 Stock market collapses and Gauguin loses job.

1883 Becomes a full-time artist. Fifth child born.

1884 Moves to Rouen, then Copenhagen, with his family.

1885 Estrangement from Mette. Gauguin moves to Paris.

1886 Paints in Pont-Aven and Le Pouldu in Brittany. Meets Emile Bernard. Makes ceramics under the guidance of Ernest Chaplet in Paris.

1887 Mette goes to Paris, taking Clovis and paintings with her when she leaves. Trip to Panama and Martinique with Charles Laval. Returns ill from dysentery and malaria. Theo van Gogh, at Boussod and Valadon, becomes his dealer.

1888 Gauguin, Laval, and Bernard work together in Pont-Aven. Paints *The Vision after the Sermon*. October, paints with van Gogh in Arles at the Yellow House; leaves after van Gogh's breakdown.

1889 Universal Exhibition. Stays with Emile Schuffenecker. Both organize *Impressionist et Synthetist* exhibition. Paints in Le Pouldu, supported by Meyer de Haan; both decorate Marie Henry's inn.

1891 Article by Albert Aurier, the critic, sets Gauguin at figurehead of modern painting. Leaves France for Tahiti, April 1. Arrival in Papeete, June 9. Moves from Papeete to remoter part of the island. Paints Tahitian women and landscape.

1893 Return to Europe. Two sales, one at the Drouot Hotel, financially unsuccessful. Writes and illustrates his Tahitian journal, *Noa Noa*.

1894 Paints in Brittany. Loses case against Marie Henry, who was looking after his paintings while in Tahiti. Sculpts his favourite piece, *Oviri*, in Chaplet's studio.

1895 Returns to Tahiti, has hut built for him in Punaauia.

1897 Daughter Aline dies, January 19. Suffers from worsening syphilis, heart attacks, and various infections. Paints *Where do we come from? What are we? Where are we going?*, before attempting suicide.

1898 Works in Public Works Department. Soon unable to paint or walk.

1899 Gauguin involved in the politics of the island; starts his own broadsheet, *Le Sourire* ("The Smile").

1900 Editor of satirical journal, *Les Guêpes* ("The Wasps").

1901 Settles in the Marquesas Islands, in Hiva-oa, about 1,300 km (800 miles) from Tahiti. Regular salary from the dealer Vollard.

1902 Feud with Bishop Martin; angers the colonials with his corrupting morals.

1903 Charged and sentenced to three months imprisonment for libel against the Governor; Gauguin dies at Atuana, May 8; public auction held of his household goods.

1903 Vollard holds Gauguin Exhibition.

1906 Retrospective of Gauguin's work in Paris begins to establish his reputation.

The view from Gauguin's grave

Gauguin collections

The following shows the locations of museums and galleries around the world that own three or more works by Gauguin.

ASIA AND OCEANIA
French Polynesia
Tahiti Musée Gauguin

Japan
Tokyo Bridgestone Museum of Art; National Museum of Western Art

NORTH AND SOUTH AMERICA
Boston Museum of Fine Arts
Chicago Art Institute of Chicago
Cleveland Cleveland Museum of Art
New York Metropolitan Museum of Art; Museum of Modern Art
San Antonio Marion Koogler Mcnay Art Institute Museum
São Paulo Museu de Arte
Washington, DC National Gallery of Art

EUROPE
Belgium
Brussels Musées Royaux des Beaux-Arts

Czechoslovakia
Prague Národní Galerie

Denmark
Copenhagen Ny Carlsberg Glyptotek; Ordrupgaardsamlingen

France
Paris Musée d'Orsay
Saint-Germain-en-laye Musée Départemental du Prieuré

Germany
Cologne Wallraf-Richartz Museum
Essen Folkwang Museum
Munich Neue Pinakothek

Netherlands
Amsterdam Rijksmuseum Vincent van Gogh

Norway
Oslo Nasjonalgalleriet

Russian Federation
Moscow Pushkin Museum
St. Petersburg The Hermitage

Sweden
Stockholm Nationalmuseum

Switzerland
Basel Kunstmuseum
Geneva Musée du Petit Palais
Zurich Stiftung Sammlung E. G. Bührle

UK
Edinburgh National Gallery of Scotland
Glasgow The Burrell Collection
London Courtauld Institute Galleries; Tate Gallery